P9-CCA-415

In Search of
Duende

THE NEW DIRECTIONS *Bibelots*

JORGE LUIS BORGES • EVERYTHING AND NOTHING

KAY BOYLE • THE CRAZY HUNTER

H.D. • KORA AND KA

SHUSAKU ENDO • FIVE BY ENDO

RONALD FIRBANK • CAPRICE

F. SCOTT FITZGERALD • THE JAZZ AGE

GUSTAVE FLAUBERT • A SIMPLE HEART

JOHN OF PATMOS • THE APOCALYPSE

DENISE LEVERTOV • MAKING PEACE

FEDERICO GARCÍA LORCA • IN SEARCH OF DUENDE

THOMAS MERTON • THOUGHTS ON THE EAST

HENRY MILLER • A DEVIL IN PARADISE

YUKIO MISHIMA • PATRIOTISM

PABLO NERUDA • SPAIN IN OUR HEARTS

OCTAVIO PAZ • A TALE OF TWO GARDENS

VICTOR PELEVIN • 4 BY PELEVIN

EZRA POUND • DIPTYCH ROME-LONDON

WILLIAM SAROYAN • FRESNO STORIES

DELMORE SCHWARTZ • SCREENO

GARRY SNYDER • LOOK OUT

MURIEL SPARK • THE ABBESS OF CREWE
THE DRIVER'S SEAT

DYLAN THOMAS • EIGHT STORIES

TENNESSEE WILLIAMS • THE ROMAN SPRING OF
MRS. STONE

WILLIAM CARLOS WILLIAMS • ASPHODEL, THAT
GREENY FLOWER & OTHER LOVE POEMS

FEDERICO GARCÍA LORCA

IN SEARCH OF DUENDE

PROSE SELECTIONS EDITED AND TRANSLATED BY
CHRISTOPHER MAURER

POEMS TRANSLATED BY NORMAN DI GIOVANNI,
EDWIN HONIG, LANGSTON HUGHES, LYSANDER
KEMP, W. S. MERWIN, STEPHEN SPENDER,
J. L. GILI, AND CHRISTOPHER MAURER

A NEW DIRECTIONS

Bibelot

Copyright © 1955, 1998 by New Directions Publishing Corporation
Copyright © Herederos de Federico García Lorca
Translations by Christopher Maurer Copyright © Christopher Maurer
and Herederos de Federico García Lorca

All rights, including performance rights, are reserved throughout
the world by Herederos de Federico García Lorca and the translator.
All enquiries should be addressed to William Peter Kosmas, Esq.,
77 Rodney Court, 6/8 Maida Vale, London W9 1TJ, England.

Manufactured in the United States of America.
New Directions Books are printed on acid-free paper.
First published as a New Directions Bibelot in 1998.
Published simultaneously in Canada by Penguin Books Canada Limited.

Library of Congress Cataloging-in-Publication Data

García Lorca, Federico, 1898–1936.
 In search of duende / Federico García Lorca ; translators, Norman di
Giovanni . . . [et al.] ; prose selections edited and translated by
Christopher Maurer.
 p. cm.
 "A New Directions Bibelot."
 ISBN 978-0-8112-1376-9 (alk. paper)
 1. García Lorca, Federico, 1898–1936—Translations into English.
2. Creation (Literary, artistic, etc.) 3. Performing arts—Spain—
Andalusia. I. Di Giovanni, Norman Thomas. II. Maurer,
Christoper. III. Title.
PQ6613.A762A2263 1998
868'.6209—dc21 97–47161
 CIP

New Directions Books are published for James Laughlin
by New Directions Publishing Corporation
80 Eighth Avenue, New York 10011

EIGHTH PRINTING

Table of Contents

Preface vii
Deep Song 1
Note on the Guitar 24
The Guitar 26
Riddle of the Guitar 28
Poem of the Saeta 28
Rider's Song 38
Farewell 40
Death of Antoñito el Camborio 40
Ballad of One Doomed to Die 44
Play and Theory of the Duende 48
In Praise of Antonia Mercé, *La Argentina* 63
Lament for Ignacio Sánchez Mejías 66
Poem of the Bull 82
Dance of the Moon in Santiago 86
Casida of the Branches 88
Casida of the Lament 90
Gacela of the Bitter Root 92
Notes 95

Preface

In New York, in the fall of 1929, García Lorca wrote to his parents in Granada, asking them for a copy of a lecture he had given years earlier on the Andalusian music known as *cante jondo*, or "deep song." It was an "important subject," he told them, "and I want to present [that lecture] as a polemic, first in Cuba and then in Spain."

Lorca's lecture (pp. 1–23) had been given to win support for the Festival of Cante Jondo organized in Granada in 1922 by Manuel de Falla, Lorca, and others. Drawing on Falla's research on the structure and origins of *cante jondo*, Lorca hoped to imbue it with prestige among Spanish intellectuals, and distinguish it from the commercially adulterated professional "flamenco" heard in urban cafés and theaters. The young poet saw cante jondo as a strictly rural phenomenon, an intimate and anonymous cry of pain and longing, a folk music, best sung by amateurs, which the Gypsies had brought from the Orient to the "melting pot" of Andalusia. Its sober, haunting melody and style were collective, and in that sense *impersonal*, creations. The four- or five-line lyrics "belong to no one," Lorca wrote. "They float in the wind like golden thistledown."

It seems to have been in New York, while writing *Poet in New York*, listening to jazz, blues, and negro spirituals, and studying English at Columbia University, that Lorca grew dissatisfied with that early, Romantic theory of cante jondo as anonymous, amateur folksong: "impersonal, vague, unconscious creation." In a revised version of his lecture, written after he had had more personal contact with profes-

sional cantaores (singers) and bailaores (dancers) like Manuel Torre or Pastora Pavón and with classical dancers like Antonia Mercé, *La Argentina,* he states unequivocally that "the difference between a good and a bad cantaor is that the first has duende, and the second never, ever achieves it."

> The duende is a momentary burst of inspiration, the blush of all that is truly alive, all that the performer is creating at a certain moment. The duende resembles what Goethe called the "demoniacal." It manifests itself principally among musicians and poets of the spoken word, rather than among painters and architects, for it needs the trembling of the moment and then a long silence.[1]

By 1930, cante jondo no longer seemed a "collective" creation, and the singer no longer seemed a passive "medium" for the "voice of the people." All three of its principal elements—singing, dance (p. 63), and guitar accompaniment (p. 24)—depended upon the "personality" of an individual performer, and upon his or her search for the spirit known as duende.

Over the next few years, the duende became much more than an explanation for the power of certain performers of cante jondo. By 1933, when Lorca read his lecture "Play and Theory of the Duende" (pp. 48–62) to an enthusiastic audience in Buenos Aires, it had become a cornerstone of his poetics. These were years when Lorca's poetry was turning away from the logic of traditional metaphor to images which attempt to evade rational analysis and to produce (in his words) "poetic emotion which is uncontrolled and virginal, free of walls, a freestanding poetry with its own newly created laws"; a world of mysterious images "without explainable causes and effects."[2]

[1] From the revised version of "Deep Song," entitled "Architecture of Deep Song," in C. Maurer, *FGL y su "Arquitectura del cante jondo"* (Granada: Casa-Museode FGL, 1997).

[2] From "Imaginación, inspiración, evasión" in FGL, *Conferencias,* Vol. II, ed. C. Maurer (Madrid: Alianza, 1984), p. 15.

The notion of duende (from *duen de casa*, "master of the house") came to him from popular Spanish culture, where the duende is a playful hobgoblin, a household spirit fond of hiding things, breaking plates, causing noise, and making a general nuisance of himself. But Lorca was aware of another popular usage of the term. In Andalusia people say of certain toreros and flamenco artists that they *have* duende—an inexplicable power of attraction, the ability, on rare occasions, to send waves of emotion through those watching and listening to them. It is this aspect of duende which the poet demonstrates, and elaborates upon, in his lecture.

At least four elements can be isolated in his vision of duende: irrationality, earthiness, a heightened awareness of death, and a dash of the diabolical. The duende is a demonic earth spirit who helps the artist see the limitations of intelligence, reminding him that "ants could eat him or that a great arsenic lobster could fall suddenly on his head"; who brings him face-to-face with death; and who helps him create and communicate memorable, spine-chilling art. The duende is seen, in Lorca's lecture, as an alternative to style, to mere virtuosity, to God-given grace and charm (what Spaniards call "ángel"), and to the classical, artistic norms dictated by the muse. Not that the artist simply *surrenders* to the duende; he or she has to battle it skillfully, "on the rim of the well," in "hand-to-hand combat."

To a higher degree than the muse or the angel, the duende seizes not only the performer but also the audience, creating conditions where art can be understood spontaneously with little, if any, conscious effort. It is, in Lorca's words, "a sort of corkscrew that gets art into the sensibility of an audience . . . the very dearest thing that life can offer to an intellectual."[3] The critic Brook Zern has written, of a performance of someone with duende: "it dilates the mind's eye, so that the intensity becomes almost unen-

[3]*Obras completas*, ed. Arturo del Hoyo, vol. III (Madrid: Aguilar, 1986), pp. 556, 574.

durable. . . . There is a quality of first-timeness, of reality so heightened and exaggerated that it becomes unreal, and this is characterized by a remarkable time-distortion effect which is frequent in nightmares. . . . A friend of mine, emerging from Seville's bullring after Curro Romero's last great triumph there in 1966, put it like this: 'Time moved like that for me once before—when I was in a crashing car.' "[4]

Given its supposed effects on the public, it is no wonder that Lorca invoked the duende before reading *Poet in New York,* one of his most difficult books, before large audiences in Spain and Latin America. Poet and audience must make themselves more vulnerable, he said:

> Let us agree that one of man's most beautiful postures is that of Saint Sebastian. Well then, before reading poems aloud before many creatures, the first thing one must do is invoke the duende. That is the only way that everybody will immediately succeed at the hard task of understanding metaphor (without depending on critical apparatus or intelligence) and be able to catch, at the speed of the voice, the rhythmic design of the poem.[5]

Compiled on the centenary of his birth, this little book gathers Lorca's writings about the duende and about three of the art forms most susceptible to it: dance, cante jondo, and the bullfight. A sampling of Lorca's poetry is also included, with special attention to poems that arise from traditional Spanish verse forms, "bound," as Lorca says, "to the earth, all thistles and terminal stones." All of these poems deal in some way with death.

The texts from *Poem of the Deep Song* (pp. 26–38) were written a few months before the 1922 Festival, and published nine years later. They testify to Lorca's belief that tra-

[4]"Ghost Story"; unpublished manuscript.

[5]From a reading in 1932 reprinted in *Poet in New York*, ed. C. Maurer, tr. Greg Simon and Steven F. White, 2nd ed. (New York: Farrar, Straus & Giroux, 1998).

ditional verse—flamenco lyrics, the ballad, the folksong—must not be "copied" too literally, and that the poet must draw from them "nothing but the very essence and this or that trill for its coloristic effect," a lesson he had learned from the stylized folklore of the Ballets Russes, and from his mentor Manuel de Falla.

"Farewell" (p. 40) and "Rider's Song" (p. 38), a little ballad, are from Lorca's next book, *Songs* (1927), and another two poems have been drawn from his best-known collection, *The Gypsy Ballads* (1928). Antoñito el Camborio dies at the hands of his Gypsy cousins, who are taking revenge for some unexplained affront (like traditional ballads, this one begins mysteriously, in medias res), and "Ballad of One Doomed to Die" draws on a childhood memory of a deathly apparition. The great *Lament for Ignacio Sánchez Mejías* commemorates a friend mortally wounded in a provincial bullring in August 1934 and protests against the disappearance of "an Andalusian so true, so rich in adventure." Lorca remarked to a friend that Sanchez Mejías's death was like "an apprenticeship for my own," which came two years later. "Dance of the Moon in Santiago" (p. 86), from *Six Galician Poems,* written in the regional tongue of northwestern Spain, was inspired by the parallelistic traditional poetry cultivated in Galicia since the Middle Ages.

The poems from *Divan of the Tamarit,* a distant homage to classical Arabic verse forms, are the gravest ever written by Lorca. In them, as in deep song, love and death come inextricably together. Like the essays on duende and deep song, they search for the "bitter root" of human existence, what Lorca referred to as "the pain which has no explanation": familiar ground to the cantaor and to the duende, and the source of much great art.

<div align="right">Christopher Maurer</div>

Deep Song

You have gathered tonight in the salon of the Centro Artístico to hear my simple but sincere word, and I would like it to be luminous and profound, in order to convince you of the marvelous artistic truth contained in the primitive Andalusian music known as "deep song."

The intellectuals and enthusiastic friends backing the idea of this Festival are only sounding an alarm. Ladies and gentlemen, the musical soul of the people is in great danger! The artistic treasure of an entire race is passing into oblivion. Each day another leaf falls from the admirable tree of Andalusian lyrics, old men carry off to the grave priceless treasures of past generations, and a gross, stupid avalanche of cheap music clouds the delicious folk atmosphere of all Spain.

We are trying to do something worthy and patriotic. This is a labor of preservation, friendship, and love.

You have all heard of deep song and have some idea what it is. But to those unaware of its historical and artistic transcendence it almost certainly suggests immoral things, the tavern, the late-night orgy, the dance floors of flamenco cafés, ridiculous whining—in short, all that is "typically Spanish"!—and we must guard against this for the sake of Andalusia, our millennial spirit, and each of our own hearts.

It does not seem possible that the deepest, most moving songs of our mysterious soul should be maligned as debauched and dirty; that people should want to tie to the orgiast's guitar the thread that connects us to the impenetra-

ble Orient, and dash the dark wine of the professional pimp on the most diamantine part of our song.

And so the time has come for musicians, poets, and Spanish artists to unite their voices in an instinct of preservation, in order to define and exalt the limpid beauty and suggestiveness of these songs.

To confuse the patriotic and artistic ideals of this Festival with the lamentable vision of the cantaor with his little tap-stick and his vulgar wailing about cemeteries would show total ignorance and misunderstanding of what has been planned. On reading the announcement for this Festival, every sensible man uninformed on the matter will ask, "What is deep song?"

Before going ahead, we ought to make a special distinction between deep song and flamenco—an essential distinction based on their relative antiquity, structure, and spirit.

The name deep song is given to a group of Andalusian songs whose genuine, perfect prototype is the Gypsy siguiriya. The siguiriya gave rise to other songs still sung by the people: polos, martinetes, carceleras, and soleares. The songs called malagueñas, granadinas, rondeñas, peteneras, etc., must be considered mere offshoots of the songs mentioned above, for they differ in both architecture and rhythm. These latter songs form the repertory of so-called flamenco.

The great maestro Manuel de Falla, true glory of Spain and soul of this Festival, believes that with their primitive style, the caña and the playera, which have all but disappeared, have the same composition as the siguiriya and its related forms, and that not too long ago they were its simple variants. Relatively recent texts make him suppose that during the first third of the nineteenth century the caña and the playera occupied the place we assign today to the Gypsy siguiriya. Estébanez Calderón, in his lovely *Escenas andaluzas,* notes that the caña is the primitive trunk of the songs retaining their Arab and Moorish filiation, and ob-

2

serves, with characteristic perspicacity, that the word "caña" much resembles the word "gannia," which is Arabic for song.

The essential difference between deep song and flamenco is that the origins of the former must be sought in the primitive musical systems of India, in the very first manifestations of song, while flamenco, a mere consequence of deep song, did not acquire its definitive form until the eighteenth century.

Deep song is imbued with the mysterious color of primordial ages; flamenco is relatively modern song whose emotional interest pales before that of deep song. Local color versus spiritual color; that is the profound difference.

Like the primitive Indian musical systems, deep song is a stammer, a wavering emission of the voice, a marvelous buccal undulation that smashes the resonant cells of our tempered scale, eludes the cold, rigid staves of modern music, and makes the tightly closed flowers of the semitones blossom into a thousand petals.

Flamenco does not proceed by undulation but by leaps. Its rhythm is as sure as that of our own music, and it was born centuries after Guido of Arezzo had named the notes.

Deep song is akin to the trilling of birds, the crowing of the rooster, and the natural music of forest and fountain.

It is a very rare specimen of primitive song, the oldest in all Europe, and its notes carry the naked, spine-tingling emotion of the first Oriental races.

Maestro Falla, who has made a profound study of the subject, and on whose work I document my own, affirms that the Gypsy siguiriya is the prototype of deep song, and he roundly declares that it is perhaps the only genre of song on our continent that has preserved in all its purity, both structurally and stylistically, the most important characteristics of the primitive song of Oriental peoples.

But even before I knew of the Maestro's opinion, the

3

Gypsy siguiriya had always evoked (I am an incurable lyricist) an endless road, a road without crossroads, ending at the pulsing fountain of the child Poetry. The road where the first bird died and the first arrow grew rusty.

The Gypsy siguiriya begins with a terrible scream that divides the landscape into two ideal hemispheres. It is the scream of dead generations, a poignant elegy for lost centuries, the pathetic evocation of love under other moons and other winds.

Then the melodic phrase begins to pry open the mystery of the tones and remove the precious stone of the sob, a resonant tear on the river of the voice. No Andalusian can help but shudder on hearing that scream. No regional song has comparable poetic greatness. Seldom—very seldom—has the human spirit been able to create works of that sort.

Do not think that the siguiriya and its variants are simply songs transplanted from the Orient to the West. No. According to Falla, it would be truer to say they were grafted upon native stock. Better said, this was a matter of coinciding sources which certainly were not revealed all of a sudden, but grew from accumulated secular, historical events on our Peninsula. Thus it is that the song of Andalusia, though essentially like that of a people geographically remote from us, possesses its own intimate, unmistakable national character.

The historical events Falla says have influenced our songs are these: the Spanish Church's adoption of Byzantine liturgical chant; the Saracen invasion; and the arrival in Spain of numerous bands of Gypsies. These are the mysterious roving folk who gave deep song its final form.

The Gypsy influence is shown by the term "Gypsy siguiriya" and by the extraordinary number of Gypsy words in the texts of the songs.

Not that this chant is purely Gypsy: the Gypsies live all

4

over Europe and in all regions of the Peninsula, but these songs are cultivated only by our Andalusian ones.

Deep song is a purely Andalusian chant, which was budding in this region even before the Gypsies came.

The Maestro notes these essential similarities between deep song and certain extant songs of India: the use of "enharmonism" to modulate the melody; a melodic ambit that rarely goes beyond a sixth; and the reiterated, almost obsessive prolongation of a single note, a procedure proper to certain techniques of hypnosis and certain forms of prehistoric recitation (a fact which has led many to suppose that song came before language).

And this is why deep song produces the impression of chanted prose, destroying any sense of metrical rhythm, though in fact the lyrics are three- or four-lined stanzas with feminine rhyme.

Falla writes:

> The melody of deep song is rich in ornamental turns, but they are used only at certain moments, like expansions or sudden gusts brought on by the emotional strength of the poem. We must think of them more as ample vocal inflections than as ornament, although they resemble the latter when translated into the geometric intervals of the tempered scale.

One can say for sure that in deep song, as in the songs from the heart of Asia, the musical gamut is a direct consequence of what we might call the oral gamut.

Many authors suppose that word and song were once the same thing and Louis Lucas in his *Acoustique nouvelle* (Paris, 1840) says, while discussing the excellence of the enharmonic genre, "It is the first which appears in Nature, through the imitation of birdsong, the cries of animals, and the infinite sounds of matter."

Hugo Riemann, in his *Musical Aesthetics,* affirms that the song of birds is close to being true music, and cannot be

treated differently than the song of men, insofar as both are the expression of sensibilities.

The great Maestro Felipe Pedrell, one of the first Spaniards to study folklore scientifically, writes in his magnificent *Cancionero musical popular español:* "Musical orientalism persists in various popular Spanish songs and is deeply rooted in our nation because of the influence of the ancient Byzantine civilization on the rites of the Spanish Church. This influence extended from the conversion of our country to Christianity until the eleventh century when the Roman liturgy . . . was introduced."

Falla adds to what his old teacher has said and identifies the specific elements of Byzantine liturgical chant found in the siguiriya: the tonal modes of primitive systems (not to be confused with the so-called Greek modes); the enharmonism of those modes; and the melody line's lack of metrical rhythm. "These same factors are present in certain Andalusian songs that came much later than the adoption of Byzantine liturgical music by the Spanish Church: songs which have an affinity with the music still known in Morocco, Algiers, and Tunis as (and this will move all true Granadans) 'Music of the Moors of Granada.'"

But to return to the analysis of the siguiriya, Falla, with his solid musical knowledge and exquisite intuition, has found in it "certain forms and characteristics related neither to sacred chant nor to the 'Music of the Moors of Granada.'" That is, having plumbed the strange melody of deep song, Falla has found an extraordinary agglutinative Gypsy element. He accepts the historical thesis that gives the Gypsies an Indic origin; and that thesis seems to agree marvelously with his fascinating research.

According to the thesis, in the year 1400 the Gypsies, pursued by the hundred-thousand horsemen of the great Tamerlane, fled from India.

Twenty years later these tribes appeared in different European cities and entered Spain with the Saracen armies then periodically arriving (from Egypt and Arabia) on our coasts.

When they arrived in Andalusia the Gypsies combined ancient, indigenous elements with what they themselves brought, and gave what we now call deep song its definitive form.

So it is to them we owe the creation of these songs, soul of our soul. We owe the Gypsies the building of these lyrical channels through which all the pain, all the ritual gestures of the race can escape.

And these are the songs, ladies and gentlemen, that for over fifty years Spaniards have tried to confine to fetid taverns and brothels. The terrible, doubting epoch of Grilo, of the Spanish zarzuela and of historical painting, is to blame.[1] While Russia burned with love for folklore, the one source, as Robert Schumann once said, of all true, characteristic art, and while the golden wave of Impressionism trembled in France, in Spain, a country almost unique in her tradition of popular beauty, the guitar and deep song were scorned.

The prejudice has become so widespread that we must now cry out to defend songs so pure and true.

That is the way the spiritual youth of Spain understands it.

From when Jovellanos called attention to the lovely, incoherent danza prima of Asturias until the time of the great Don Marcelino Menéndez y Pelayo, great progress was made in understanding popular culture. Isolated artists and minor poets studied these questions from different points of view and, eventually, a useful, patriotic gathering of songs and poems got under way. Proof of this are the *Songbook of Burgos* by Federico Olmeda, the *Songbook of Salamanca* by Dámaso Ledesma, and Eduardo Martínez Torner's *Asturian*

7

Songbook, all generously subsidized by the respective provincial governments.

But the way we can really gauge the importance of deep song is by its almost decisive influence on the formation of the modern Russian school and by the high esteem of the French composer Claude Debussy, that lyrical argonaut, discoverer of a new musical world.

In 1847 Mikhail Ivanovich Glinka came to Granada. He had been in Berlin studying composition with Siegfried Dehn and had observed the musical patriotism of Weber struggling against the pernicious influence of the Italian composers in Germany. Glinka was deeply impressed with the songs of immense Russia, and he dreamed of a natural music, a national music, that would convey some feeling of her grandeur.

The visit to our city by the father and founder of the Slavic-Orientalist school is more than curious. He made friends with a celebrated guitarist of those days, Francisco Rodríguez *el Murciano;* for hours on end he listened to him play the variations and guitar runs of our songs. Amid the eternal rhythm of Granada's waters Glinka conceived the magnificent idea of creating his school and found the courage to use the whole-tone scale for the first time.

When he returned to his people he announced the good news and explained the peculiarities of our songs, which he studied and used in his music.

Music changes direction! At last the composer has found its true source!

Glinka's friends and disciples turn to folklore and seek structures for their creations not only in Russia but in the south of Spain.

Proof of this are Glinka's *Souvenirs d'une nuit d'été à Madrid* and parts of the *Scheherezade* and *Capriccio espagnol* of Nicolai Rimsky-Korsakov, pieces you all know.

Imagine the influence, all the way from Granada to

Moscow, of the sad modulations and sober orientalism of our deep song, as the mysterious bells of the Kremlin catch the melancholy of the bell of the Vela.[2]

At the Spanish Pavilion of the great Paris Exhibition of 1900, a group of Gypsies sang deep song in all its purity. They caught the attention of the whole city, but especially a young musician who was then engaged in the fight all of us young artists must carry on, the fight for what is new and unforeseen, the treasure hunt, in the sea of thought, for inviolate emotion.

Day after day that young man went to hear the Andalusian cantaores. His soul was wide open to the four winds of the spirit, and he was soon made pregnant by the ancient Orient of our melodies. He was Claude Debussy.

Later he would define new theories and climb to the very summit of European music.

Sure enough, from his compositions rise the subtlest evocations of Spain, above all of Granada, a city he knew for what it really is: paradise.

Claude Debussy, composer of fragrance and of pure sensation, reaches his highest creative pitch in the poem *Iberia*, a truly genial work in which Andalusian perfumes and essences dreamily float.

But where he reveals precisely how much he was influenced by deep song is in the marvelous prelude titled *La Puerta del Vino* and in the vague, tender *Soirée en Grenade*, where, I think, one can find all the emotional themes of nighttime in Granada, the blue remoteness of the Vega, the Sierra greeting the tremulous Mediterranean, the enormous barbs of the clouds sunk into the distance, the admirable rubato of the city, the hallucinating play of its underground waters.

And the most remarkable thing about all this is that Debussy, though he seriously studied our song, never saw Granada.

It is a stupendous case of artistic divination, of profound and brilliant intuition, which I mention in praise of the great composer and to the honor of our people. It reminds me of the great mystic Swedenborg when he saw, all the way from London, the burning of Stockholm, and of the profound prophecies of the saints of antiquity.

In Spain deep song has had an undeniable influence on all of our best composers, from Albéniz through Granados to Falla. Felipe Pedrell had already used popular song in his magnificent opera *La Celestina* (to our shame never performed in Spain) and had shown where we were headed. But the masterstroke was left to Isaac Albéniz, who plumbed the depths of Andalusian song in his work. Years later Manuel de Falla fills his music with our motifs, beautiful and pure in their remote, spectral form. The latest generation of Spanish composers, like Adolfo Salazar, Roberto Gerhard, Federico Mompou, and our own Angel Barrios, enthusiastic supporters of this Festival, are training their sight on the pure, revivifying font of deep song and on the delightful songs of Granada, songs that might well be called Castilian-Andalusian.

Notice, ladies and gentlemen, the transcendence of deep song, and how rightly our people called it "deep." It is truly deep, deeper than all the wells and seas in the world, much deeper than the present heart that creates it or the voice that sings it, because it is almost infinite. It comes from remote races and crosses the graveyard of the years and the fronds of parched winds. It comes from the first sob and the first kiss.

One of the marvels of deep song, apart from the melodies, is the poems.

All us poets who to some degree are concerned with pruning and caring for the overluxuriant lyric tree left to us

10

by the Romantics and post-Romantics are astonished by these poems.

The finest degrees of Sorrow and Pain, in the service of the purest, most exact expression, pulse through the tercets and quatrains of the siguiriya and its derivatives.

There is nothing, absolutely nothing in Spain to equal the siguiriya's style, atmosphere, and emotional rightness.

The metaphors that people the Andalusian songbook fall almost always within the siguiriya's orbit. The well-proportioned spiritual members of its verses seize our hearts and hold them fast.

It is wondrous and strange how the anonymous popular poet can condense all the highest emotional moments in human life into a three- or four-line stanza. There are songs where the lyrical tremor reaches a point inaccessible to any but a few poets:

> Cerco tiene la luna; The moon has a halo;
> mi amor ha muerto. my love has died.

There is much more mystery in those two lines than in all the plays of Maeterlinck. Simple, real mystery, sound and healthy, without gloomy forests or rudderless ships. It is the living eternal enigma of death:

> The moon has a halo;
> my love has died.

Whether they come from the heart of the Sierra, the orange groves of Seville, or from harmonious Mediterranean shores, the songs have common roots: love and death. But love and death as seen by the Sibyl, that oriental personage, the true sphinx of Andalusia.[3]

Behind these poems lurks a terrible question that has no answer. Our people cross their arms in prayer, look at the stars, and wait in vain for a sign of salvation. The gesture is

11

pathetic but true. And the poem either poses a deep emotional question with no answer, or solves it with death, which is the question of questions.

Most of Andalusia's popular poems, except for many born in Seville, possess those characteristics. We are a sad, static people.

As Ivan Turgenev saw his countrymen (Russian blood and marrow turned to sphinx), so do I see many poems of our regional folk poetry. Oh sphinx of the Andalusias!

<div style="margin-left: 2em">

A mi puerta has de llamar,	You will knock at my door.
no te he de salir a abrir	I will never get up to answer,
y me has de sentir llorar.	and you must hear me cry.

</div>

Asleep behind an impenetrable veil, those lines await a passing Oedipus to awaken and decipher them, and then return them to silence.

One of the most remarkable characteristics of the deepsong poems is their almost complete lack of a restrained, middle tone.

In the songs of Asturias, as in those of Castile, Catalonia, the Basque country, and Galicia, there is a certain emotional balance, a lyrical equilibrium that lends itself to the expression of simple states of mind and naive feeling which are almost entirely absent from the Andalusian songs.

Seldom do we Andalusians notice the "middle tone." An Andalusian either shouts at the stars or kisses the red dust of the road. The middle tone does not exist for him. He sleeps right through it. And when he uses it, once in a great while, it is only to say:

<div style="margin-left: 2em">

A mí se me importa poco	It doesn't matter to me
que un pájaro en la *alamea*	if a bird in the poplar grove
se pase de un árbol a otro.	skips from tree to tree.[4]

</div>

And even this song is related to Asturian songs in sentiment, if not in design. So then, emotiveness is deep song's most striking trait.

That is why, though many of the songs of our Peninsula can make us see the landscapes where they are sung, deep song sings like a nightingale without eyes. It sings blind, for both its words of passion and its ancient tunes are best set in the night, the blue night of our countryside.

Many Spanish popular songs have this capacity for plastic evocation. But because of it they lack the intimacy and profundity of deep song.

Here is an Asturian song (one among a thousand) that will serve as a good example of this sort of "evocation."

Ay de mí, perdí el camino	Ah, I have lost the road
en esta triste montaña.	on this sad mountain.
Ay de mí, perdí el camino.	Ah, I have lost the road.
Déxame meté'l rebañu,	Let me bring the sheep
por Dios, en la to cabaña.	for God's sake into your cabin.
Entre la espesa nublina	In the dense fog
¡ay de mí, perdí el camino!	I have lost the road.
Déxame pasar la noche	Let me spend the night
en la cabaña contigo.	in the cabin with you.
Perdí el camino	I lost the road
entre la niebla del monte.	in the mountain mist.
¡Ay de mí, perdí el camino!	Ah, I have lost the road!

It is so marvelous, this evocation of a mountain, with the wind moving the pine trees; so exact the sensation of the road climbing to the drowsy snowcapped peaks; so true the sight of the mist rising from the abyss to blur the moist rocks in innumerable shades of gray—it is so marvelous that one forgets all about the "honest shepherd" who, like a little boy, asks shelter of the poem's unknown shepherd girl. "One forgets the very essence of the poem." The melody of

this song, with its monotonous green-gray rhythm of misty landscapes, is extraordinarily suggestive, almost sculptural.

In contrast, deep song always sings in the night. It knows neither morning nor evening, mountains nor plains. It has only the night, a wide night steeped in stars. Nothing else matters.

It is song without landscape, withdrawn into itself and terrible in the dark. Deep song shoots its arrows of gold right into our heart. In the dark it is a terrifying blue archer whose quiver is never empty.

The questions everybody asks—who made these poems? what anonymous poet tossed them onto the rough-hewn popular stage?—these questions cannot really be answered.

In his book *Les origines de la poésie lyrique en France,* Jeanroy writes that popular art is not only impersonal, vague, unconscious creation; it includes also the "personal" creations that the people adapt to their own sensibility. Jeanroy is partly correct, but one need not be very perceptive to discover such personal creations in hiding, however natural are the colors that camouflage them. Our people sing poems of Melchor de Palau, of Salvador Rueda, of Ventura Ruiz Aguilera, of Manuel Machado and others, but what a difference between the verse of these poets and the poems the people created themselves! It is the difference between a paper rose and a natural one!

The poets who compose "popular" songs cloud the clear lymph of the true heart. How one notices, in their poems, the confident, ugly rhythm of the man who knows grammar! Nothing but the very essence and this or that trill for its coloristic effect ought to be drawn straight from the people. We should never want to copy their ineffable modulations; we can do nothing but muddy them. Simply because of education.

The true poems of deep song belong to no one—they float in the wind like golden thistledown, and each generation dresses them in a different color and passes them on to the next.

They are fastened to an ideal weather vane changing direction in the winds of Time.

They are born, well, just because. They are one more tree in the landscape, one more spring in the poplar grove.

Woman, heart of the world and immortal keeper of "the rose, the lyre, and the science of harmony," looms on the infinite horizons of these poems. The woman of deep song is called Pain.

It is admirable how sentiment begins to take shape in these lyrical constructions and quicken into an almost material thing. This is the case with Pain.

In these poems Pain is made flesh, takes human form, and acquires a sharp profile. She is a dark woman wanting to catch birds in nets of wind.

All of the poems of deep song are magnificently pantheistic; the poets ask advice from the wind, the earth, the sea, the moon, and things as simple as a violet, a rosemary, a bird. All exterior objects assume their own striking personalities and take on active roles in the lyrical action:

En mitá del *má*
había una piedra
y se sentaba mi compañerita
a contarle sus penas.

Out in the sea
was a stone.
My girl sat down
to tell it her pains.

*

Tan solamente a la Tierra
le cuento lo que me pasa,
porque en el mundo no encuentro
persona *e* mi confianza.

Only to the Earth
do I tell my troubles,
for nowhere in the world
do I find anyone to trust.

*

15

Todas las mañanas voy
a preguntarle al romero
si el mal de amor tiene cura
porque yo me estoy muriendo.

Every morning I go
to ask the rosemary
if love's ill can be cured,
for I am dying.

With deep spiritual feeling the Andalusian entrusts Nature with his very most intimate treasure, completely confident of being listened to.

One feature of deep song, one admirable poetic reality, is the strange way the wind materializes in many of the songs.

The wind is a character who emerges in the ultimate, most intensely emotional moments. He comes into sight like a giant absorbed in pulling down stars and scattering nebulae. In no popular poetry but ours have I heard him speak and console:

Subí a la muralla.
Me respondió el viento:
¿para qué tantos suspiritos
si ya no hay remedio?

I climbed up the wall.
The wind answered me:
"Why so many little sighs
if it is already too late?"

*

El aire lloró
al ver las "duquitas" tan grandes
e mi corazón.

The wind cried
to see how big the wounds were
in my heart.

*

Yo me enamoré del aire,
del aire de una mujer.
Como la mujer es aire,
en el aire me quedé.

I fell in love with the air,
the air of a woman,
and since a woman is air,
in the air I stayed.

*

Tengo celos del aire
que da en tu cara.
Si el aire fuera hombre
yo le matara.

I'm jealous of the breeze
that blows on your face.
If the breeze were a man,
I would kill him.

16

<div style="text-align: center">*</div>

Yo no le temo a remar,	I'm not afraid of the galleys.
que yo remar remaría.	If I had to row, I'd do it.
Yo sólo temo al viento	I'm only afraid of the wind
que sale de tu bahía.	that blows out of your bay.

This is a delicious peculiarity of these poems, poems tangled in the immobile helix of the mariner's wind chart.

Another very special theme occurring in most of these songs is weeping.

In the Gypsy siguiriya, perfect poem of tears, the melody cries, and so does the poetry. There are bells lost in the deep, windows open to the dawn:

De noche me *sargo* ar patio	At night I go to the courtyard
y me *jarto* de *llorá*,	and cry my heart out,
en *vé* que te quiero tanto	to see I love you so much
y tú no me quieres *ná*.	and you love me not at all.

<div style="text-align: center">*</div>

Llorar, llorar, ojos míos,	Cry, keep crying, eyes,
llorar si tenéis por qué,	cry if you have cause.
que no es vergüenza en un hombre	It shouldn't shame a man
llorar por una mujer.	to cry over a woman.

<div style="text-align: center">*</div>

Cuando me veas llorar	When you see me cry,
no me quites el pañuelo,	don't take away my handkerchief,
que mis penitas son grandes	for I am in deep pain,
y llorando me consuelo.	and crying I feel better.

And this last one, very Andalusian and very Gypsy:

Si mi corazón tuviera	If my heart
birieritas e cristar,	had windowpanes of glass,
te asomaras y lo vieras	you'd look inside and see it
gotas de sangre llorar.	crying drops of blood.[5]

<div style="text-align: center">17</div>

These songs have an unmistakably traditional ring to them. In my judgment they are the ones best suited to the melancholy of deep song. Their sadness is so irresistible, their pathos so strong, that they cause all true Andalusians to weep inside, with tears that cleanse the spirit and carry it away to the burning lemon grove of love.

Nothing can compare with the tenderness and delicacy of these songs, and I insist that it is infamy to forget them or to prostitute them with base, sensual intention or gross caricature. But that only happens in cities. Fortunately for the virgin Poetry and for all poets, there are still sailors who sing at sea, women who rock their children to sleep in the shade of grapevines, and rustic shepherds on mountain paths. The passionate wind of poetry will blow on the dying fire, bringing the embers to life, and these people will continue to sing: the women in the shade of the grapevines, the shepherds on their bitter paths, the sailors on the fecund rhythm of the sea.

Just as very ancient oriental elements are found in the music of the siguiriya and its derivatives, so in many poems of deep song there is an affinity to the oldest oriental verse.

When our songs reach the very heights of pain and love they become the expressive sisters of the magnificent verses of Arabian and Persian poets.

The truth is that in the air of Córdoba and Granada one still finds gestures and lines of remote Arabia, and remembrances of lost cities still arise from the murky palimpsest of the Albaicín.

The same themes of sacrifice, undying love, and wine, expressed in the same spirit, appear in the works of mysterious Asiatic poets.

The Arabic poet Siraj-al-Warak says:

The turtledove that with her complaints
keeps me from sleep
has a breast that burns like mine,
with living fire.

Ibn Sa'īd, another Arabic poet, writes the same elegy
that an Andalusian would have written, on the death of his
mistress:[6]

To console me my friends say
visit your mistress's tomb.
Has she a tomb, I ask,
other than in my breast?

But where the resemblance is most striking of all is in
the sublime amorous ghazals of Hafiz, the national poet of
Persia, who sang the wine, beautiful women, mysterious
stones, and infinite blue night of Shiraz.

Since ancient times art has used wireless telegraphy and
bounced its signals off the stars.

In his ghazals Hafiz shows various poetic obsessions,
among them an exquisite obsession with tresses:

Even if she did not love me,
I would trade
the whole globe of the earth
for one hair from her tress.

And later he writes:

My heart has been ensnared
in your black tresses since childhood.
Not until death
will a bond so wonderful be undone.

The same obsession with hair is found in many of our singular deep-song poems, full of allusions to tresses preserved in reliquaries and the lock of hair on the forehead that provokes a whole tragedy. This specimen, one of many, demonstrates my point. It is a siguiriya:

Si acasito muero, mira que te encargo que con las trenzas de tu pelo negro me ates las manos.	If I should happen to die, I order you, tie up my hands with your black tresses.

There is nothing more profoundly poetic than these lines, with their sad aristocratic eroticism.

When Hafiz takes up the theme of weeping he uses the same expressions as our popular poet, with the same wispy construction, based on the same sentiments:

> I weep endlessly: you are gone.
> But what use is all my longing
> if the wind will not carry my sighs
> to your ears . . . ?

It is the same as:

Yo doy suspiros al aire, ¡ay, pobrecito de mí, y no los recoge nadie!	I sigh into the wind, Ay, poor me! But nobody catches my sighs!

Hafiz says:

> Since you stopped listening
> to the echo of my voice,
> my heart has been plunged in pain.
> It sends jets of burning blood
> to my eyes.

And our poet:

Cada vez que miro el sitio	Whenever I look at the place
donde te he solido hablar	where I used to court you,
comienzan mis pobres ojos	my poor eyes begin
gotas de sangre a llorar.	crying drops of blood.

Or this terrible poem, a siguiriya:

De aquellos *quereles*	It was a love
no quiero acordarme,	I must not remember,
porque llora mi corazoncito	for my poor heart is weeping
gotas de sangre.	drops of blood.

In the twenty-seventh ghazal the man of Shiraz sings:

> In the end my bones
> will turn to dust in the grave,
> but the soul will never be able
> to lose such a strong passion.

Which is exactly the same solution struck by countless poets of deep song: love is stronger than death.

It moved me deeply to read these Asiatic poems translated into Spanish by Don Gaspar María de Nava and published in Paris in 1838, for they immediately reminded me of our own "deepest" poems.

Then too, both our singers of the siguiriya and the oriental poets praise wine. They praise the clear, soothing wine that reminds me of girls' lips, happy wine, quite unlike the frightening Baudelairean stuff. I will cite one song (I think it is a martinete) which is sung by a character who tells us his Christian name and surname, a rare occurrence. I see all true Andalusian poets personified in him.

Yo me llamo Curro Pulla
por la tierra y por el mar,
y en la puerta de la tasca
la piedra fundamental.

They call me Curro Pulla,
on the land and on the sea.
I am the keystone
in the door of the tavern.

In these songs of Curro Pulla wine receives the highest praise. Like the marvelous Omar Khayyam, he knows that

> My love will end,
> my tears will end,
> my grief will end,
> and all will end.

Crowning himself in the roses of the moment, he gazes into a glass of nectar and sees a falling star. Like the magnificent bard of Nishapur he imagines life as a chessboard.

Ladies and gentlemen, deep song, because of both its melody and its poems, is one of the strongest popular artistic creations in the world. In your hands lies the task of preserving it and dignifying it, for the sake of Andalusia and her people.

Before I bring this poor, badly constructed lecture to a close, I want to remember the marvelous singers thanks to whom deep song has come down to our day.

The figure of the cantaor is found within two great lines, the arc of the sky on the outside, and on the inside the zigzag that wanders like a snake through his heart.

When the cantaor sings he is celebrating a solemn rite. He rouses ancient essences from their sleep, wraps them in his voice, and flings them into the wind. He has a deeply religious sense of song.

Through these chanters the race releases its pain and its true history. They are simple mediums, the lyrical crest feathers of our people.

They are strange but simple folk who sing hallucinated by a brilliant point of light trembling on the horizon.

The women have sung soleares, a melancholy human genre within easy reach of the heart. But the men have preferred the portentous Gypsy siguiriya, and almost all of them have been martyrs to an irresistible passion for deep song. The siguiriya is like a cautery that burns the heart, throat, and lips of those who utter it. One must be careful of the fire and sing it at just the right moment.

I want to remember Romerillo, the spiritual "Loco Mateo," Antonia *la de San Roque*, Anita *la de Ronda*, Dolores *la Parrala*, and Juan Breva, who sang soleares better than anyone else and invoked the virgin Pain in the lemon groves of Málaga or beneath the maritime nights of Cádiz.

And I want to remember the masters of the siguiriya: Curro *Pabla, el Curro*, Manuel Molina, Manuel Torre, and the prodigious Silverio Franconetti, who sang the song of songs better than anyone and whose scream opened quivering cracks in the moribund mercury of the mirrors.[7]

They were prodigious interpreters of the soul of the people, and they destroyed their own hearts in storms of feeling. Almost all died of heart attacks, bursting like enormous cicadas after lacing our atmosphere with ideal rhythms.

Ladies and gentlemen:

If you have ever been moved by the distant song that comes down the road; if your ripe hearts have ever been pinched by the white dove of Love; if you love the tradition that is strung (as beads are strung) upon the future; whether you study books or plow the earth—I respectfully appeal to all of you not to allow the precious living jewels of the race—the immense, thousand-year-old treasure that covers the spiritual surface of Andalusia—not to let that die. May you meditate, on this night in Granada, on the patriotic transcendence of the project which a handful of Spanish artists are about to present.

Note on the Guitar

Deep song has two marvels, apart from its melodic line: the guitar and the lyrics.

There can be no doubt that the guitar has given form to many of the songs of Andalusia, for they have had to adapt to its tonality. Proof of this is that the songs which are sung without guitar accompaniment, such as martinetes and jelianas, change form completely, acquiring greater liberty and a movement that is less constructed and more direct.

In deep song the role of the guitar is to mark the rhythm and submit to the singer. It is but background for the voice.

And yet, because the guitarist's personality is as distinct as that of the singer, the guitarist too must sing, and this gives rise to the falseta, which is the strings' commentary, very beautiful when it is sincere, but often false, foolish, and full of senseless Italianisms when played by one of those so-called virtuosos who accompany the singers of fandangos in the lamentable spectacle known as "flamenco opera."

The falseta too has a long tradition, and some guitarists, like the magnificent *Niño de Huelva*, allow themselves to be carried along on the voice of their good blood, without straying from the pure line or attempting (although the *Niño de Huelva* is a true virtuoso) to demonstrate their virtuosity. I have spoken of "the voice of their good blood" because the first thing required for singing and playing is a certain capacity for transforming and purifying the melody and rhythm, and this is what the Andalusian possesses, especially the Gypsy. He has a certain wisdom that

allows him to eliminate the new, the merely accessory, and discover the essence: a magical knowledge of how to sketch or measure a siguiriya with an absolutely millennial accent. The guitar comments, but it also creates, and this is one of the greatest dangers facing deep song. There are times when a guitarist, wanting to show off, completely destroys the emotion of the lyrics, or ruins a final flourish.

No doubt the guitar has constructed deep song. It has worked upon the dark, oriental, Jewish, and Arabic substance of the song, which babbles in its old age like a child. The guitar has made deep song into something Western. It has created unequaled beauty out of the Andalusian drama—the struggle of the Orient and the West—which has made Baetica an island of true culture.

La guitarra

Empieza el llanto
de la guitarra.
Se rompen las copas
de la madrugada.
Empieza el llanto
de la guitarra.
Es inútil
callarla.
Es imposible
callarla.
Llora monótona
como llora el agua,
como llora el viento
sobre la nevada.
Es imposible
callarla.
Llora por cosas
lejanas.
Arena del Sur caliente
que pide camelias blancas.
Llora flecha sin blanco,
la tarde sin mañana,
y el primer pájaro muerto
sobre la rama.
¡Oh guitarra!
Corazón malherido
por cinco espadas!

The Guitar

The guitar
begins its weeping.
The wineglasses of dawn
are shattered.
The guitar
begins its weeping.
It is useless
to hush it.
Impossible
to hush it.
It cries monotonously,
as the water cries,
as the wind cries
over the snowfield.
It is impossible
to hush it.
It cries
for distant things.
Sand from the hot South
asking for white camellias.
It cries, arrow with no target,
evening with no morning,
and the first bird
dead on the branch.
Oh guitar!
Heart mortally wounded
by five swords.

CHRISTOPHER MAURER

Adivinanza de la guitarra

En la redonda
encrucijada,
seis doncellas
bailan.
Tres de carne
y tres de plata.
Los sueños de ayer las buscan
pero las tiene abrazadas
un Polifemo de oro.
¡La guitarra!

Poema de la saeta

Arqueros

Los arqueros oscuros
a Sevilla se acercan.

Guadalquivir abierto.

Anchos sombreros grises,
largas capas lentas.

¡Ay, Guadalquivir!

Vienen de los remotos.
países de la pena.

Riddle of the Guitar

At the round
crossroads,
six maidens
are dancing.
Three of flesh,
three of silver.
Yesterday's dreams pursue them,
but they are held fast
by a golden Polyphemus.
The guitar!

CHRISTOPHER MAURER

Poem of the Saeta

Archers

The dark archers
approach Seville.

The open Guadalquivir.

Broad gray hats,
long slow cloaks.

Ay, Guadalquivir!

They come from remote
regions of sorrow.

Guadalquivir abierto.

Y van a un laberinto.
Amor, cristal y piedra.

¡Ay, Guadalquivir!

Noche

Cirio, candil,
farol y luciérnaga.

La constelación
de la saeta.

Ventanitas de oro
tiemblan,
y en la aurora se mecen
cruces superpuestas.

Cirio, candil,
farol y luciérnaga.

Sevilla

Sevilla es una torre
llena de arqueros finos.

Sevilla para herir.
Córdoba para morir.

Una ciudad que acecha
largos ritmos,
y los enrosca

The open Guadalquivir.

And they go to a labyrinth.
Love, crystal, and rock.

Ay, Guadalquivir!
LYSANDER KEMP

Night

Candle, lamp,
lantern, and firefly.

The constellation
of the dart.

Little windows of gold
trembling,
and cross upon cross
rocking in the dawn.

Candle, lamp,
lantern, and firefly.
JAIME DE ANGULO

Seville

Seville is a tower
full of fine archers.

Seville to wound.
Córdoba to die in.

A city that lurks
for long rhythms,
and twists them

como laberintos.
Como tallos de parra
encendidos.

¡Sevilla para herir!

Bajo el arco del cielo,
sobre su llano limpio,
dispara la constante
saeta de su río.

¡Córdoba para morir!

Y loca de horizonte,
mezcla en su vino
lo amargo de Don Juan
y lo perfecto de Dionisio.

Sevilla para herir.
¡Siempre Sevilla para herir!

Procesion

Por la calleja vienen
extraños unicornios.
¿De qué campo,
de qué bosque mitológico?
Más cerca,
ya parecen astrónomos.
Fantásticos Merlines
y el Ecce Homo,
Durandarte encantado.
Orlando furioso.

like labyrinths.
Like tendrils of a vine
burning.

Seville to wound!

Under the arch of the sky,
across the clear plain,
she shoots the constant
arrow of her river.

Córdoba to die in!

And mad with horizons,
she mixes in her wine
the bitterness of Don Juan
and the perfection of Dionysus.

Seville to wound.
Always Seville to wound!

LYSANDER KEMP

Procession

Through the lanes
come strange unicorns.
From what fields,
from what mythological forest?
Nearer,
they look like astronomers.
Fantastic Merlins,
and the Ecce Homo.
Enchanted Durandarte.
Orlando Furioso.

LYSANDER KEMP

Paso

Virgen con miriñaque,
virgen de la Soledad,
abierta como un immenso
tulipán.
En tu barco de luces
vas
por la alta marea
de la ciudad,
entre saetas turbias
y estrellas de cristal.
Virgen con miriñaque,
tú vas
por el río de la calle,
¡hasta el mar!

Saeta

Cristo moreno
pasa
de lirio de Judea
a clavel de España.

¡Miradlo por dónde viene!

De España.
Cielo limpio y oscuro,
tierra tostada,
y cauces donde corre
muy lenta el agua.
Cristo moreno,
con las guedajas quemadas,

Paso

Virgin in crinoline,
Virgin of Solitude,
opened like an immense
tulip.
In your ship of lights
you go
along the high tide
of the city,
among turbid saetas
and crystal stars.
Virgin in crinoline,
you go
down the river of the street
to the sea!

<div style="text-align: right">LYSANDER KEMP</div>

Arrow

Brown Christ
passes
from the lily of Judea
to the carnation of Spain.

Look where he comes!

From Spain.
Sky clear and dark,
parched land,
and watercourses where very
slowly runs the water.
Brown Christ,
with the burned forelocks,

los pómulos salientes
y las pupilas blancas.

¡Miradlo por dónde va!

Balcon

La Lola
canta saetas.
Los toreritos
la rodean,
y el barberillo
desde su puerta,
sigue los ritmos
con la cabeza.
Entre la albahaca
y la hierbabuena,
la Lola canta
saetas.
La Lola aquella,
que se miraba
tanto en la alberca.

Madrugada

Pero como el amor
los saeteros
están ciegos.

Sobre la noche verde
las saetas,
dejan rastros de lirio
caliente.

the jutting cheekbones
and the white pupils.

Look where he goes!

W. S. MERWIN

Balcony

Lola
sings saetas.
The little bullfighters
circle around her
and the little barber,
from his doorway,
follows the rhythms
with his head.
Between the sweet basil
and the mint,
Lola sings
saetas.
That same Lola
who looked so long
at herself in the pool.

W. S. MERWIN

Early Morning

But like love,
the archers
are blind.

Over the green night
the arrows
leave tracks of warm
lilies.

La quilla de la luna
rompe nubes moradas
y las aljabas
se llenan de rocío.

¡Ay, pero como el amor
los saeteros
están ciegos!

Cancion de jinete

Córdoba.
Lejana y sola.

Jaca negra, luna grande,
y aceitunas en mi alforja.

Aunque sepa los caminos
yo nunca llegaré a Córdoba.

Por el llano, por el viento,
jaca negra, luna roja.
La muerte me está mirando
desde las torres de Córdoba.

¡Ay qué camino tan largo!
¡Ay mi jaca valerosa!
¡Ay que la muerte me espera,
antes de llegar a Córdoba!

Córdoba.
Lejana y sola.

The keel of the moon
breaks purple clouds
and the quivers
fill with dew.

Ah, but like love,
the archers
are blind!

<div align="right">W. S. MERWIN</div>

Rider's Song

Córdoba.
Far away and alone.

Black pony, big moon,
and olives in my saddlebag.
Although I know the roads
I'll never reach Córdoba.

Through the plain, through the wind,
black pony, red moon.
Death is looking at me
from the towers of Córdoba.

Ay! How long the road!
Ay! My valiant pony!
Ay! That death should wait for me
before I reach Córdoba.

Córdoba.
Far away and alone.

<div align="right">STEPHEN SPENDER AND J. L. GILI</div>

Despedida

Si muero,
dejad el balcón abierto.

El niño come naranjas.
(Desde mi balcón lo veo.)

El segador siega el trigo.
(Desde mi balcón lo siento.)

¡Si muero,
dejad el balcón abierto!

Muerte de Antoñito el Camborio

Voces de muerte sonaron
cerca del Guadalquivir.
Voces antiguas que cercan
voz de clavel varonil.
Les clavó sobre las botas
mordiscos de jabalí.
En la lucha daba saltos
jabonados de delfín.
Bañó con sangre enemiga
su corbata carmesí,
pero eran cuatro puñales

Farewell

If I die,
leave the balcony open.

The little boy is eating oranges.
(From my balcony I can see him.)

The reaper is harvesting the wheat.
(From my balcony I can hear him.)

If I die,
leave the balcony open!

<div align="right">W. S. MERWIN</div>

The Death of Antoñito el Camborio

Voices of death resounded
near the Guadalquivir.
Ancient voices which surround
voice of manly carnation.
He nailed through their boots
bites of wild boar.
In the fight he leapt
like the slippery dolphin.
He bathed in enemy blood
his crimson tie,
but there were four daggers

y tuvo que sucumbir.
Cuando las estrellas clavan
rejones al agua gris,
cuando los erales sueñan
verónicas de alhelí,
voces de muerte sonaron
cerca del Guadalquivir.

—Antonio Torres Heredia,
Camborio de dura crin,
moreno de verde luna,
voz de clavel varonil:
¿Quién te ha quitado la vida
cerca del Guadalquivir?
—Mis cuatro primos Heredias
hijos de Benamejí.
Lo que en otros no envidiaban,
ya lo envidiaban en mí.
Zapatos color corinto,
medallones de marfil,
y este cutis amasado
con aceituna y jazmín.
—¡Ay, Antoñito el Camborio,
digno de una Emperatriz!
Acuérdate de la Virgen
porque te vas a morir.
—¡Ay, Federico García,
llama a la Guardia Civil!
Ya mi talle se ha quebrado
como caña de maiz.

Tres golpes de sangre tuvo,
y se murió de perfil.
Viva moneda que nunca
se volverá a repetir.
Un ángel marchoso pone

and he could only succumb.
When the stars nail
spears on the grey water,
when the yearlings dream
verónicas of gillyflowers,
voices of death resounded
near the Guadalquivir.

—Antonio Torres Heredia,
an authentic Camborio,
dark of green moon,
voice of manly carnation:
Who took your life away
near the Guadalquivir?
—My four cousins the Heredias,
sons of Benamejí.
They did not envy in others
what they envied in me.
Raisin-coloured shoes,
ivory medallions,
and this skin kneaded
of olive and jasmine.
—Ah, Antoñito of the Camborios
worthy of an Empress!
Remember the Virgin
because you are to die.
—Ah, Federico García,
call the Guardia Civil!
Already my waist has snapped
like a stalk of maize.

Three gushes of blood,
and he died in profile.
Living coin which never
will be repeated.
A swaggering angel places

su cabeza en un cojín.
Otros de rubor cansado,
encendieron un candil.
Y cuando los cuatro primos
llegan a Benamejí,
voces de muerte cesaron
cerca del Guadalquivir.

Romance del emplazado

¡Mi soledad sin descanso!
Ojos chicos de mi cuerpo
y grandes de mi caballo,
no se cierran por la noche
ni miran al otro lado
donde se aleja tranquilo
un sueño de trece barcos.
Sino que limpios y duros
escuderos desvelados,
mis ojos miran un norte
de metales y peñascos
donde mi cuerpo sin venas
consulta naipes helados.

Los densos bueyes del agua
embisten a los muchachos
que se bañan en las lunas
de sus cuernos ondulados.
Y los martillos cantaban
sobre los yunques sonámbulos,
el insomnio del jinete
y el insomnio del caballo.

his head on a cushion.
Others with a wearied blush
lighted an oil lamp.
And when the four cousins
arrive at Benamejí,
voices of death ceased
near the Guadalquivir.

 STEPHEN SPENDER AND J. L. GILI

Ballad of One Doomed to Die

Loneliness without rest!
The little eyes of my body
and the big eyes of my horse
never close at night
nor look that other way
where quietly disappears
a dream of thirteen boats.
Instead, clean and hard,
squires of wakefulness,
my eyes look for a north
of metals and of cliffs
where my veinless body
consults frozen playing cards.

Heavy water-oxen charge
boys who bathe in the moons
of their rippling horns.
And the hammers sing
on the somnambulous anvils
the insomnia of the rider
and the insomnia of the horse.

El veinticinco de junio
le dijeron a el Amargo:
—Ya puedas cortar si gustas
las adelfas de tu patio.
Pinta una cruz en la puerta
y pon tu nombre debajo,
porque cicutas y ortigas
nacerán en tu costado,
y agujas de cal mojada
te morderán los zapatos.
Será de noche, en lo oscuro,
por los montes imantados
donde los bueyes del agua
beben los juncos soñando.
Pide luces y campanas.
Aprende a cruzar las manos
y gusta los aires fríos
de metales y peñascos.
Porque dentro de dos meses
yacerás amortajado.

Espadón de nebulosa
mueve en el aire Santiago.
Grave silencio, de espalda,
manaba el cielo combado.

El veinticinco de junio
abrió sus ojos Amargo,
y el veinticinco de agosto
se tendió para cerrarlos.
Hombres bajaban la calle
para ver al emplazado,
que fijaba sobre el muro
su soledad con descanso.
Y la sábana impecable,
de duro acento romano,
daba equilibrio a la muerte
con las rectas de sus paños.

On the twenty-fifth of June
they said to Amargo:
—Now, you may cut, if you wish,
the oleanders in your courtyard.
Paint a cross on your door
and put your name beneath it,
for hemlock and nettle
shall take root in your side
and needles of wet lime
will bite into your shoes.
It will be night, in the dark,
in the magnetic mountains
where water-oxen drink
in the reeds, dreaming.
Ask for lights and bells.
Learn to cross your hands,
to taste the cold air
of metals and of cliffs
because within two months
you'll lie down shrouded.

Santiago moved his misty
sword in the air.
Dead silence flows over
the shoulder of the curved sky.

On the twenty-fifth of June
Amargo opened his eyes,
and the twenty-fifth of August
he lay down to close them.
Men came down the street
to look upon the doomed one
who cast on the wall his shadow
of loneliness at rest.
And the impeccable sheet
with its hard Roman accent
gave death a certain poise
by the rectitude of its folds.

LANGSTON HUGHES

47

Play and Theory of the Duende

Ladies and gentlemen:

From 1918, when I entered the Residencia de Estudiantes de Madrid, until 1928, when I finished my studies in Philosophy and Letters and left, I attended, in that elegant salon where the old Spanish aristocracy did penance for its frivolous seaside vacations in France, around one thousand lectures.

Hungry for air and for sunlight, I used to grow so bored as to feel myself covered by a light film of ash about to turn into sneezing powder.

And that is why I promise never to let the terrible botfly of boredom into *this* room, stringing your heads together on the fine thread of sleep and putting tiny pins and needles in your eyes.

As simply as possible, in the register of my poetic voice that has neither the glow of woodwinds nor bends of hemlocks, nor sheep who suddenly turn into knives of irony, I shall try to give you a simple lesson in the hidden, aching spirit of Spain.

Whoever finds himself on the bull's hide stretched between the Júcar, Guadalfeo, Sil, and Pisuerga rivers—not to mention the great streams that empty their churning water into the tawny Plata—often hears people say, "This has much duende." Manuel Torre, great artist of the Andalusian people, once told a singer, "You have a voice, you know the styles, but you will never triumph, because you have no duende."[1]

All over Andalusia, from the rock of Jaén to the whorled

shell of Cádiz, the people speak constantly of the "duende," and identify it accurately and instinctively whenever it appears. The marvelous singer El Lebrijano, creator of the debla, used to say, "On days when I sing with duende, no one can touch me." The old Gypsy dancer La Malena once heard Brailowsky play a fragment of Bach and exclaimed, "Olé! That has duende!" but was bored by Gluck, Brahms, and Darius Milhaud. Manuel Torre, who had more culture in the blood than any man I ever met, pronounced this splendid sentence on hearing Falla play his own *Nocturno del generalife:* "All that has black sounds has duende." And there is no greater truth.

These "black sounds" are the mystery, the roots fastened in the mire that we all know and all ignore, the fertile silt that gives us the very substance of art. "Black sounds," said that man of the Spanish people, concurring with Goethe, who defined the duende while speaking of Paganini: "A mysterious power which everyone senses and no philosopher explains."[2]

The duende, then, is a power, not a work. It is a struggle, not a thought. I have heard an old maestro of the guitar say, "The duende is not in the throat; the duende climbs up inside you, from the soles of the feet." Meaning this: it is not a question of ability, but of true, living style, of blood, of the most ancient culture, of spontaneous creation.

This "mysterious power which everyone senses and no philosopher explains" is, in sum, the spirit of the earth, the same duende that scorched the heart of Nietzsche, who searched in vain for its external forms on the Rialto Bridge and in the music of Bizet, without knowing that the duende he was pursuing had leaped straight from the Greek mysteries to the dancers of Cádiz or the beheaded, Dionysian scream of Silverio's siguiriya.[3]

But I do not want anyone to confuse the duende with the theological demon of doubt at whom Luther, with bac-

49

chic feeling, hurled a pot of ink in [Eisenach], nor with the destructive and rather stupid Catholic devil who disguises himself as a bitch to get into convents, nor with the talking monkey carried by Cervantes' Malgesí in his comedy entitled *Jealousy and the Forest of Ardenia*.

No. The duende I am talking about is the dark, shuddering descendant of the happy marble-and-salt demon of Socrates, whom he angrily scratched on the day Socrates swallowed the hemlock, and of that melancholy demon of Descartes: a demon who was small as a green almond and who sickened of circles and lines and escaped down the canals to listen to the songs of blurry sailors.

Every man and every artist, whether he is Nietzsche or Cézanne, climbs each step in the tower of his perfection by fighting his duende, not his angel, as has been said, nor his muse. This distinction is fundamental, at the very root of the work.

The angel guides and gives like Saint Raphael, defends and avoids like Saint Michael, announces and forewarns like Saint Gabriel.

The angel dazzles, but he flies high over a man's head, shedding his grace, and the man effortlessly realizes his work or his charm or his dance. The angel on the road to Damascus, and the one that came through the crack of the little balcony of Assisi, and the one who tracked Heinrich Suso are all *ordering*, and it is useless to resist their lights, for they beat their steel wings in an atmosphere of predestination.

The muse dictates and sometimes prompts. She can do relatively little, for she is distant and so tired (I saw her twice) that one would have to give her half a heart of marble. Poets who have muses hear voices and do not know where they are coming from. They come from the muse that encourages them and sometimes snacks on them, as happened to Apollinaire, a great poet destroyed by the horrible

muse who appears with him in a certain painting by the divine, angelic Rousseau. The muse awakens the intelligence, bringing a landscape of columns and a false taste of laurel. But intelligence is often the enemy of poetry, because it limits too much, and it elevates the poet to a sharp-edged throne where he forgets that ants could eat him or that a great arsenic lobster could fall suddenly on his head— things against which the muses that live in monocles and in the lukewarm, lacquered roses of tiny salons are quite helpless.

The muse and angel come from outside us: the angel gives lights, and the muse gives forms (Hesiod learned from her). Loaf of gold or tunic fold: the poet receives norms in his grove of laurel. But one must awaken the duende in the remotest mansions of the blood.

And reject the angel, and give the muse a kick in the seat of the pants, and conquer our fear of the violet smile exhaled by eighteenth-century poetry, and of the great telescope in whose lens the muse, sickened by limits, is sleeping.

The true fight is with the duende.

We know the roads where we can search for God, from the barbarous way of the hermit to the subtle one of the mystic. With a tower like Saint Teresa or with the three ways of Saint John of the Cross. And though we may have to cry out in the voice of Isaiah, "Truly thou art a hidden God," in the end God sends each seeker his first fiery thorns.

But there are neither maps nor exercises to help us find the duende. We only know that he burns the blood like a poultice of broken glass, that he exhausts, that he rejects all the sweet geometry we have learned, that he smashes styles, that he leans on human pain with no consolation and makes Goya (master of the grays, silvers, and pinks of the best English painting) work with his fists and knees in horrible bitumens. He strips Mossèn Cinto Verdaguer in the cold of

51

the Pyrenees, or takes Jorge Manrique to watch for death in the wasteland of Ocaña, or dresses Rimbaud's delicate body in the green suit of a saltimbanque, or puts the eyes of a dead fish on the Comte de Lautréamont in the late-night hours of the boulevard.

The great artists of the south of Spain, whether Gypsy or flamenco, whether they sing, dance, or play, know that no emotion is possible unless the duende comes. They may be able to fool people into thinking they have duende—authors and painters and literary fashionmongers do so every day—but we have only to pay a little attention and not surrender to indifference in order to discover the fraud and chase away their clumsy artifice.

The Andalusian singer Pastora Pavón, *La Niña de los Peines*, dark Hispanic genius whose powers of fantasy are equal to those of Goya or Rafael el Gallo, was once singing in a little tavern in Cádiz. For a while she played with her voice of shadow, of beaten tin, her moss-covered voice, braiding it into her hair or soaking it in wine or letting it wander away to the farthest, darkest bramble patches. No use. Nothing. The audience remained silent.

In the same room was Ignacio Espeleta, handsome as a Roman turtle, who had once been asked, "How come you don't work?" and had answered, with a smile worthy of Argantonius, "Work? Why? I'm from Cádiz!" And there was Hot Elvira, aristocratic Sevillian whore, direct descendant of Soledad Vargas who in 1930 refused to marry a Rothschild because he was not of equal blood. And the Floridas, whom the people take to be ranchers, but who are really millennial priests who still sacrifice bulls to Geryon. And in one corner sat the formidable bull rancher Don Pablo Murube, with the air of a Cretan mask. When Pastora Pavón finished singing there was total silence, until a tiny man, one of those dancing manikins that rise suddenly out of brandy bottles, sarcastically murmured "Long live Paris!" As if to

say: "Here we care nothing about ability, technique, skill. Here we are after something else."

As though crazy, torn like a medieval mourner, *La Niña de los Peines* leaped to her feet, tossed off a big glass of burning liquor, and began to sing with a scorched throat: without voice, without breath or color, but with duende. She was able to kill all the scaffolding of the song and leave way for a furious, enslaving duende, friend of sand winds, who made the listeners rip their clothes with the same rhythm as do the blacks of the Antilles when, in the "lucumí" rite, they huddle in heaps before the statue of Santa Bárbara.

La Niña de los Peines had to tear her voice because she knew she had an exquisite audience, one which demanded not forms but the marrow of forms, pure music, with a body lean enough to stay in the air. She had to rob herself of skill and security, send away her muse and become helpless, that her duende might come and deign to fight her hand-to-hand. And how she sang! Her voice was no longer playing. It was a jet of blood worthy of her pain and her sincerity, and it opened like a ten-fingered hand around the nailed but stormy feet of a Christ by Juan de Juni.

The duende's arrival always means a radical change in forms. It brings to old planes unknown feelings of freshness, with the quality of something newly created, like a miracle, and it produces an almost religious enthusiasm.

In all Arabic music, whether dance, song, or elegy, the duende's arrival is greeted with energetic cries of *Allah! Allah!*, which is so close to the Olé of the bullfight that who knows if it is not the same thing? And in all the songs of the south of Spain the duende is greeted with sincere cries of *¡Viva Dios!*—deep and tender human cry of communication with God by means of the five senses, thanks to the duende, who shakes the body and voice of the dancer. It is a real and poetic evasion of this world, as pure as that of the

strange seventeenth-century poet Pedro Soto de Rojas with his seven gardens, or that of John Climacus with his trembling ladder of lamentation.

Naturally, when this evasion succeeds, everyone feels its effects, both the initiate, who sees that style has conquered a poor material, and the unenlightened, who feel some sort of authentic emotion. Years ago, an eighty-year-old woman won first prize at a dance contest in Jerez de la Frontera. She was competing against beautiful women and young girls with waists supple as water, but all she did was raise her arms, throw back her head, and stamp her foot on the floor. In that gathering of muses and angels—beautiful forms and beautiful smiles—who could have won but her moribund duende, sweeping the ground with its wings of rusty knives.

All arts are capable of duende, but where it finds greatest range, naturally, is in music, dance, and spoken poetry, for these arts require a living body to interpret them, being forms that are born, die, and open their contours against an exact present.

Often the duende of the composer passes into the duende of the interpreter, and at other times, when a composer or poet is no such thing, the interpreter's duende—this is interesting—creates a new marvel that looks like, but is not, the primitive form. This was the case of Eleonora Duse, possessed by duende, who looked for plays that had failed so she could make them triumph thanks to her own inventions, and the case of Paganini, as explained by Goethe, who made one hear deep melodies in vulgar trifles, and the case of a delightful little girl I saw in Puerto de Santa María singing and dancing that horrible, corny Italian song "Oh Marí!" with such rhythms, silences, and intention, that she turned the Neapolitan gewgaw into something new and totally unprecedented that could give lifeblood and art to bodies devoid of expressiveness.

Every art and in fact every country is capable of duende, angel, and muse. And just as Germany has, with few exceptions, muse, and Italy shall always have angel, so in all ages Spain is moved by the duende, for it is a country of ancient music and dance where the duende squeezes the lemons of death—a country of death, open to death.

Everywhere else, death is an end. Death comes, and they draw the curtains. Not in Spain. In Spain they open them. Many Spaniards live indoors until the day they die and are taken out into the sunlight. A dead man in Spain is more alive as a dead man than anyplace else in the world. His profile wounds like a barber's razor. The joke about death and its silent contemplation are familiar to every Spaniard. From Quevedo's *Dream of the Skulls* to Valdés Leal's *Putrescent Archbishop,* from seventeenth-century Marbella who says, while dying of childhood in the middle of the road:

La sangre de mis entrañas	The blood of my womb
cubriendo el caballo está.	is covering the horse.
Las patas de tu caballo	Your horse's hoofs
echan fuego de aquiltrán . . .	throw off black fire . . .[4]

to the more recent youth of Salamanca who is killed by a bull and moans:

Amigos, que yo me muero;	Friends, I'm dying.
Amigos, yo estoy muy malo.	Friends, it's pretty bad.
Tres pañuelos tengo dentro,	Three handkerchiefs in me,
y este que meto son cuatro . . .	And this one makes a fourth . . .[5]

stretches a balustrade of saltpeter flowers where the Spanish people go to contemplate death. To one side, the more rugged one, are the verses of Jeremiah, and to the other, more lyrical side is an aromatic cypress. But throughout the country, everything finds its final, metallic value in death.

The chasuble and the cart wheel and the razor and the prickly beards of the shepherds and the naked moon and the fly and moist pantry shelves and demolished buildings and lace-covered saints and lime and the wounding edges of eaves and miradors possess, in Spain, fine weeds of death, the allusions and murmurings (perceptible to any alert spirit) that fill our memory with the stale air of our own passage. It is no accident that Spanish art is tied to the land, all thistles and terminal stones. The lamentation of Pleberio, the dances of Maestro Josef María de Valdivielso, are not isolated examples, and it is hardly a matter of chance that this beloved Spanish ballad stands apart from all others in Europe:[6]

—Si tú eres mi linda amiga,	If you are my pretty friend,
¿cómo no me miras, di?	why don't you look at me?
—Ojos con que te miraba	The eyes I looked at you with
a la sombra se los di.	I have given to the dark.
—Si tú eres mi linda amiga,	If you are my pretty friend,
¿cómo no me besas, di?	why don't you kiss me?
—Labios con que te besaba	The lips I kissed you with
a la tierra se los di.	I have given to the earth.
—Si tú eres mi linda amiga,	If you are my pretty friend,
¿cómo no me abrazas, di?	why don't you hold me tight?
—Brazos con que te abrazaba	The arms I hugged you with
de gusanos los cubrí.	are covered now in worms.[7]

Nor is it strange that this song is heard at the very dawn of our lyric poetry:

Dentro del vergel	In the garden
moriré,	I will die.
dentro del rosal	In the roses
matar me han.	they will kill me.
Yo me iba, mi madre,	I was going, mother,
las rosas coger,	to pick roses,
hallara la muerte	to find death

dentro del vergel.	in the garden.
Yo me iba, madre,	I was going, mother,
las rosas cortar,	to cut roses,
hallara la muerte	to find death
dentro del rosal.	among the roses.
Dentro del vergel	In the garden
moriré,	I will die,
dentro del rosal	in the roses
matar me han.	they will kill me.[8]

The moon-frozen heads painted by Zurbarán, the butter yellow and lightning yellow of El Greco, the narrative of Father Sigüenza, the entire work of Goya, the apse of the church of the Escorial, all polychromed sculpture, the crypt of the house of the Duke of Osuna, the "Death with a Guitar" in the Chapel of the Benaventes at Medina de Rioseco—all these mean the same, in high culture, as the processions of San Andrés de Teixido, where the dead play a role[9], the dirges sung by Asturian women with flame-filled torches in the November night,[10] the chant and dance of the Sibyl in the cathedrals of Mallorca and Toledo, the dark "In Recort" of Tortosa,[11] and the innumerable rites of Good Friday which, along with the supremely civilized festival of the bullfight, are the popular triumph of Spanish death. In all the world, only Mexico can take my country's hand.

When the muse sees death arrive, she closes the door or raises a plinth or promenades an urn and writes an epitaph with waxen hand, but soon she is watering her laurel again in a silence that wavers between two breezes. Beneath the broken arch of the ode she joins with funereal feeling the limpid flowers of fifteenth-century Italian painters, and asks Lucretius's trusty rooster to frighten away unforeseen shades.

When the angel sees death come, he flies in slow circles and weaves tears of narcissus and ice into the elegy we have seen trembling in the hands of Keats, Villasandino, Herrera, Bécquer, and Juan Ramón Jiménez. But how it

horrifies him to feel even the tiniest spider on his tender, rosy foot!

And the duende? The duende does not come at all unless he sees that death is possible. The duende must know beforehand that he can serenade death's house and rock those branches we all wear, branches that do not have, will never have, any consolation.

With idea, sound, or gesture, the duende enjoys fighting the creator on the very rim of the well. Angel and muse escape with violin, meter, and compass; the duende wounds. In the healing of that wound, which never closes, lie the strange, invented qualities of a man's work.

The magical property of a poem is to remain possessed by duende that can baptize in dark water all who look at it, for with duende it is easier to love and understand, and one can be *sure* of being loved and understood. In poetry this struggle for expression and communication is sometimes fatal.

Think of the case of Saint Teresa, that supremely "flamenco" woman who was so filled with duende. "Flamenco" not because she caught a bull and gave it three magnificent passes (which she did!) and not because she thought herself very lovely in the presence of Fray Juan de Miseria, nor because she slapped the papal nuncio, but because she was one of the few creatures whose duende—not angel, for the angel never attacks—transfixed her with a dart and wanted to kill her for having stolen his deepest secret, the subtle bridge that unites the five senses with the raw wound, that living cloud, the stormy ocean of timeless Love.

Most valiant conquerer of the duende, the very opposite of Philip of Austria, who pined after the muse and angel in theology and was finally imprisoned by a duende of freezing ardor in the palace of the Escorial, where geometry borders on dream and the duende wears the mask of the muse to the eternal punishment of that great king.

We have said that the duende loves the rim of the wound, and that he draws near places where forms fuse together into a yearning superior to their visible expression.

In Spain, as among the peoples of the Orient, where the dance is religious expression, the duende has unlimited range over the bodies of the dancers of Cádiz, praised by Martial, over the breasts of singers, praised by Juvenal, and in the liturgy of the bulls, an authentic religious drama where, as in the Mass, a God is sacrificed to and adored.

It seems as if all the duende of the classical world has crowded into this perfect festival, revealing the culture, the sensitivity of a people who discover man's best anger, bile, and weeping. Neither in Spanish dance nor in the bullfight does anyone amuse himself. The duende takes it upon himself to make us suffer by means of a drama of living forms, and clears the stairways for an evasion of the surrounding reality.

The duende works on the body of the dancer as the wind works on sand. With magical power he changes a girl into a lunar paralytic, or brings an adolescent blush to the broken old man begging in the wineshop, or the odor of a nocturnal port to a woman's hair, and he works continuously on the arms with expressions that give birth to the dances of every age.

But he can never repeat himself. This is interesting to emphasize. The duende does not repeat himself, any more than do the forms of the sea during a squall.

The duende is at his most impressive in the bullfight, for he must fight both death, which can destroy him, and geometry—measurement, the very basis of the festival.

The bull has his orbit, and the bullfighter has his, and between these two orbits is a point of danger, the vertex of the terrible play.

You can have muse with the muleta and angel with the

banderillas and pass for a good bullfighter, but in the cape-work, when the bull is still clean of wounds, and at the moment of the kill, you need the duende's help to achieve artistic truth.

The bullfighter who scares the audience with his bravado is not bullfighting, but has ridiculously lowered himself to doing what anyone can do—risking his life. But the torero bitten by duende gives a lesson in Pythagorean music and makes us forget he is always tossing his heart over the bull's horns.

From the crepuscule of the ring, Lagartijo with his Roman duende, Joselito with his Jewish duende, Belmonte with his baroque duende, and Cagancho with his Gypsy duende show poets, painters, musicians, and composers the four great roads of Spanish tradition.

Spain is the only country where death is a national spectacle, the only one where death sounds long trumpet blasts at the coming of spring, and Spanish art is always ruled by a shrewd duende who makes it different and inventive.

The duende who for the first time in sculpture smears blood on the cheeks of the saints of Maestro Mateo de Compostela is the same one that makes Saint John of the Cross weep or burns naked nymphs in the sacred sonnets of Lope.

The duende that raises the tower of Sahagún or bakes hot bricks in Calatayud or Teruel is the same one who breaks the clouds of El Greco and kicks Quevedo's constables and Goya's chimeras, sending them flying.

When he rains he brings duende-ridden Velázquez out from behind the monarchic grays where he is hiding. When he snows he makes Herrera take off his clothes to show that the cold does not kill.[12] When he burns he shoves Berruguete into the flames and makes him invent a new space for sculpture.

The muse of Góngora and the angel of Garcilaso must

let go of their laurel garlands when the duende of Saint John of the Cross comes by and

el ciervo vulnerado	the wounded stag
por el otero asoma.	comes to the hill.

The muse of Gonzalo de Berceo and the angel of the Arcipreste de Hita must withdraw to make way for Jorge Manrique mortally wounded at the doors of the castle of Belmonte. The muse of Gregorio Hernández and the angel of José de Mora must yield to the duende (crying tears of blood) of Pedro de Mena and to the duende (with the head of an Assyrian bull) of Martínez Montañés; just as the melancholy muse of Catalonia and the dripping angel of Galicia look with love and wonder at the duende of Castile—the duende with its norms of clean-scrubbed sky and dry land, the angel and muse with their warm bread and gentle cow.

Duende of Quevedo and duende of Cervantes, one with green anemones of phosphorus and the other with blossoms of Ruidera gypsum, crown the reredos of the duende of Spain.[13]

Each art has a duende different in form and style, but their roots meet in the place where the black sounds of Manuel Torre come from—the essential, uncontrollable, quivering, common base of wood, sound, canvas, and word.

Behind those black sounds, tenderly and intimately, live zephyrs, ants, volcanoes, and the huge night, straining its waist against the Milky Way.

Ladies and gentlemen: I have raised three arches, and with clumsy hand have placed in them the angel, the muse, and the duende.

The muse stays still. She can have a minutely folded tunic or cow eyes like the ones that stare at us in Pompeii,

or the huge, four-faceted nose given to her by her great friend Picasso. The angel can ruffle the hair of Antonello de Messina, the tunic of Lippi, and the violin of Masolino or Rousseau.

The duende. . . . Where is the duende? Through the empty arch comes a wind, a mental wind blowing relentlessly over the heads of the dead, in search of new landscapes and unknown accents; a wind that smells of baby's spittle, crushed grass, and jellyfish veil, announcing the constant baptism of newly created things.

In Praise of Antonia Mercé, *La Argentina*

Ladies and gentlemen:

In the art of the dance, the body struggles against the invisible mist that envelops it and tries to bring to light the dominant profile demanded by the architecture of the music. Ardent struggle, endless vigil, like all art. While the poet wrestles with the horses in his brain and the sculptor wounds his eyes on the hard spark of alabaster, the dancer battles the air around her, air that threatens at any moment to destroy her harmony or to open huge empty spaces where her rhythm will be annihilated.

The dancer's trembling heart must bring everything into harmony, from the tips of her shoes to the flutter of her eyelashes, from the ruffles of her dress to the incessant play of her fingers. Shipwrecked in a field of air, she must measure lines, silences, zigzags, and rapid curves, with a sixth sense of aroma and geometry, without ever mistaking her terrain. In this she resembles the torero, whose heart must keep to the neck of the bull. Both of them face the same danger—he, death; and she, darkness.

She must fill a dead, gray space with a living, clear, trembling arabesque, one which can be vividly remembered. This is how she speaks, this is her tongue. And in all the world, no one is as good as Antonia Mercé at inscribing the drowsy air with that arabesque of blood and bone. She combines her intuition of dance with a rhythmic intelligence and an understanding of bodily forms possessed by

63

only the great masters of the Spanish dance, among whom I would number Joselito, Lagartijo and, above all, Belmonte, who took meager forms and gave them a definitive profile, begging at times for the plinth of Rome.

This Spanish woman—the lean, dry, nervous woman who is seated here, hanging in suspense—is a heroine of her own body. She is a tamer of her own facile desires, which are always the most tempting. She has earned the reward of pure dance: double vision. I mean that when she dances her eyes are not trained on herself; they are looking ahead, governing her movements, making her expressions more objective, and helping her receive the blind, impressive bursts of pure instinct.

Just as Andalusian deep song surpasses in complexity, intelligence, and musical wealth the old oriental songs, dark and full of monotony, Spanish dance brings us both the perfume of the ancient religious dances of the East and the culture, serenity, and measure of the West, the world of criticism. The marvelous thing about Spanish dance is that here, as in *cante jondo,* there is room for personality, and thus for the contribution of the individual. There is room for modernity and for personal genius. A modern dancer from India, aside from her personal, human grace, dances as they have always danced and, generally speaking, follows eternal norms. A Spanish dancer or singer or torero does not simply resuscitate, he invents and creates a unique, inimitable art, which disappears after his death.

This is what I wanted to say about the very personal art of *La Argentina*, creator and inventor, Spanish and universal. All of the classical dances of this great artist are hers alone; they are her unique and personal "word." But they are also the word of her country, and mine. Spain does not repeat herself and, although Antonia Mercé has the grace of the fabled ballerinas of Cádiz who danced in the imperial banquets of Rome, and the same national spirit of the splendid

dancers who enthused the audiences of Lope de Vega, today, in New York, she dances with her own inimitable accent, newly born, inseparable from her body.

Antonia, these friendly women of the Cosmopolitan Club wanted me to speak today so that you could be honored in your own tongue. And I speak of you with the greatest affection. My word may not be eloquent, but it is Spanish. By just law of time (blessed be that law!) your dance will be lost in the heavens, where it is awaited by the trembling voices of masters like Silverio, Paquirri, and Juan Breva, and the nameless singers of Asturias, and the virile throats of Aragón. But your prodigious rhythm, your fresh, eternal rhythm, will return to where you found it. It will return to the living center where fire, rock, and air wound each other and purify themselves, winning, each day, new immortality for Spain.

Llanto por Ignacio Sánchez Mejías

1. La cogida y la muerte

A las cinco de la tarde.
Eran las cinco en punto de la tarde.
Un niño trajo la blanca sábana
a las cinco de la tarde.
Una espuerta de cal ya prevenida
a las cinco de la tarde.
Lo demás era muerte y sólo muerte
a las cinco de la tarde.

El viento se llevó los algodones
a las cinco de la tarde.
Y el óxido sembró cristal y níquel
a las cinco de la tarde.
Ya luchan la paloma y el leopardo
a las cinco de la tarde.
Y un muslo con un asta desolada
a las cinco de la tarde.
Comenzaron los sones de bordón
a las cinco de la tarde.
Las campanas de arsénico y el humo
a las cinco de la tarde.
En las esquinas grupos de silencio
a las cinco de la tarde,
¡Y el toro solo corazón arriba!
a las cinco de tarde.
Cuando el sudor de nieve fué llegando
a las cinco de la tarde,
cuando la plaza se cubrió de yodo
a las cinco de la tarde,

Lament for Ignacio Sánchez Mejías

1. Cogida and Death

At five in the afternoon.
It was exactly five in the afternoon.
A boy brought the white sheet
at five in the afternoon.
A trail of lime ready prepared
at five in the afternoon.
The rest was death, and death alone
at five in the afternoon.

The wind carried away the cottonwool
at five in the afternoon.
And the oxide scattered crystal and nickel
at five in the afternoon.
Now the dove and the leopard wrestle
at five in the afternoon.
And a thigh with a desolate horn
at five in the afternoon.
The bass-string struck up
at five in the afternoon.
Arsenic bells and smoke
at five in the afternoon.
Groups of silence in the corners
at five in the afternoon.
And the bull alone with a high heart!
At five in the afternoon.
When the sweat of snow was coming
at five in the afternoon,
when the bull ring was covered in iodine
at five in the afternoon.

la muerte puso huevos en la herida
a las cinco de la tarde.
A las cinco de la tarde.
A las cinco en punto de la tarde.

Un ataúd con ruedas es la cama
a las cinco de la tarde.
Huesos y flautas suenan en su oído
a las cinco de la tarde.
El toro ya mugía por su frente
a las cinco de la tarde.
El cuarto se irisaba de agonía
a las cinco de la tarde.
A lo lejos ya viene la gangrena
a las cinco de la tarde.
Trompa de lirio por las verdes ingles
a las cinco de la tarde.
Las heridas quemaban como soles
a las cinco de la tarde,
y el gentío rompía las ventanas
a las cinco de la tarde.
A las cinco de la tarde.
¡Ay, qué terribles cinco de la tarde!
¡Eran las cinco en todos los relojes!
¡Eran las cinco en sombra de la tarde!

2. La sangre derramada

¡Que no quiero verla!

Dile a la luna que venga,
que no quiero ver la sangre
de Ignacio sobre la arena.

death laid eggs in the wound
at five in the afternoon.
At five in the afternoon.
Exactly at five o'clock in the afternoon.

A coffin on wheels is his bed
at five in the afternoon.
Bones and flutes resound in his ears
at five in the afternoon.
Now the bull was bellowing through his forehead
at five in the afternoon.
The room was iridescent with agony
at five in the afternoon.
In the distance the gangrene now comes
at five in the afternoon.
Horn of the lily through green groins
at five in the afternoon.
The wounds were burning like suns
at five in the afternoon,
and the crowd was breaking the windows
at five in the afternoon.
At five in the afternoon.
Ah, that fatal five in the afternoon!
It was five by all the clocks!
It was five in the shade of the afternoon!

2. The Spilled Blood

I will not see it!

Tell the moon to come
for I do not want to see the blood
of Ignacio on the sand.

¡Que no quiero verla!

La luna de par en par.
caballo de nubes quietas,
y la plaza gris del sueño
con sauces en las barreras.

¡Que no quiero verla!

Que mi recuerdo se quema.
¡Avisad a los jazmines
con su blancura pequeña!

¡Que no quiero verla!

La vaca del viejo mundo
pasaba su triste lengua
sobre un hocico de sangres
derramadas en la arena,
y los toros de Guisando,
casi muerte y casi piedra,
mugieron como dos siglos
hartos de pisar la tierra.
No.
¡Que no quiero verla!

Por las gradas sube Ignacio
con toda su muerte a cuestas.
Buscaba el amanecer,
y el amanecer no era.
Busca su perfil seguro,
y el sueño lo desorienta.
Buscaba su hermoso cuerpo
y encontró su sangre abierta.
¡No me digáis que la vea!
No quiero sentir el chorro

I will not see it!

The moon wide open.
Horse of still clouds,
and the grey bullring of dreams
with willows in the barreras.

I will not see it!

Let my memory kindle!
Warn the jasmines
of such minute whiteness!

I will not see it!

The cow of the ancient world
passed her sad tongue
over a snout of blood
spilled on the sand,
and the bulls of Guisando,
partly death and partly stone,
bellowed like two centuries
sated with treading the earth.
No.
I do not want to see it!
I will not see it!

Ignacio goes up the tiers
with all his death on his shoulders.
He sought for the dawn
but the dawn was no more.
He seeks for his confident profile
and the dream bewilders him.
He sought for his beautiful body
and encountered his opened blood.
I will not see it!
I do not want to hear it spurt

cada vez con menos fuerza;
ese chorro que ilumina
los tendidos y se vuelca
sobre la pana y el cuero
de muchedumbre sedienta.
¿Quién me grita que me asome?
¡No me digáis que la vea!

No se cerraron sus ojos
cuando vió los cuernos cerca,
pero las madres terribles
levantaron la cabeza.
Y a través de las ganaderías,
hubo un aire de voces secretas
que gritaban a toros celestes,
mayorales de pálida niebla.
No hubo príncipe en Sevilla
que comparársele pueda,
ni espada como su espada
ni corazón tan de veras.
Como un río de leones
su maravillosa fuerza,
y como un torso de mármol
su dibujada prudencia.
Aire de Roma andaluza
le doraba la cabeza
donde su risa era un nardo
de sal y de inteligencia.
¡Qué gran torero en la plaza!
¡Qué buen serrano en la sierra!
¡Qué blando con las espigas!
¡Qué duro con las espuelas!
¡Qué tierno con el rocío!
¡Qué deslumbrante en la feria!
¡Qué tremendo con las últimas
banderillas de tiniebla!

each time with less strength:
that spurt that illuminates
the tiers of seats, and spills
over the corderoy and the leather
of a thirsty multitude.
Who shouts that I should come near!
Do not ask me to see it!

His eyes did not close
when he saw the horns near,
but the terrible mothers
lifted their heads.
And across the ranches,
an air of secret voices rose,
shouting to celestial bulls,
herdsmen of pale mist.
There was no prince in Seville
who could compare with him,
nor sword like his sword
nor heart so true.
Like a river of lions
was his marvellous strength,
and like a marble torso
his firm drawn moderation.
The air of Andalusian Rome
gilded his head
where his smile was a spikenard
of wit and intelligence.
What a great torero in the ring!
What a good peasant in the sierra!
How gentle with the sheaves!
How hard with the spurs!
How tender with the dew!
How dazzling in the fiesta!
How tremendous with the final
banderillas of darkness!

Pero ya duerme sin fin.
Ya los musgos y la hierba
abren con dedos seguros
la flor de su calavera.
Y su sangre ya viene cantando:
cantando por marismas y praderas,
resbalando por cuernos ateridos,
vacilando sin alma por la niebla,
tropezando con miles de pezuñas
como una larga, oscura, triste lengua,
para formar un charco de agonía
junto al Guadalquivir de las estrellas.

¡Oh blanco muro de España!
¡Oh negro toro de pena!
¡Oh sangre dura de Ignacio!
¡Oh ruiseñor de sus venas!

No.
¡Que no quiero verla!
Que no hay cáliz que la contenga,
que no hay golondrinas que se la beban,
no hay escarcha de luz que la enfrie,
no hay canto ni diluvio de azucenas,
no hay cristal que la cubra de plata.
No.
¡¡Yo no quiero verla!!

3. Cuerpo presente

La piedra es una frente donde los sueños gimen
sin tener agua curva ni cipreses helados.
La piedra es una espalda para llevar al tiempo
con árboles de lágrimas y cintas y planetas.

But now he sleeps without end.
Now the moss and the grass
open with sure fingers
the flower of his skull.
And now his blood comes out singing;
singing along marshes and meadows,
sliding on frozen horns,
faltering soulless in the mist,
stumbling over a thousand hoofs
like a long, dark, sad tongue,
to form a pool of agony
close to the starry Guadalquivir.

Oh, white wall of Spain!
Oh, black bull of sorrow!
Oh, hard blood of Ignacio!
Oh, nightingale of his veins!

No.
I will not see it!
No chalice can contain it,
no swallows can drink it,
no frost of light can cool it,
nor song nor deluge of white lilies,
no glass can cover it with silver.
No.
I will not see it!

3. *The Laid-Out Body*

Stone is a forehead where dreams grieve
without curving waters and frozen cypresses.
Stone is a shoulder on which to bear Time
with trees formed of tears and ribbons and planets.

Yo he visto lluvias grises correr hacia las olas
levantando sus tiernos brazos acribillados,
para no ser cazadas por la piedra tendida
que desata sus miembros sin empapar la sangre.

Porque la piedra coge simientes y nublados,
esqueletos de alondras y lobos de penumbra;
pero no da sonidos, ni cristales, ni fuego,
sino plazas y plazas y otras plazas sin muros.

Ya está sobre la piedra Ignacio el bien nacido.
Ya se acabó. ¿Qué pasa? ¡Contemplad su figura!
La muerte le ha cubierto de pálidos azufres
y le ha puesto cabeza de oscuro minotauro.

Ya se acabó. La lluvia penetra por su boca.
El aire como loco deja su pecho hundido,
y el Amor, empapado con lágrimas de nieve,
se calienta en la cumbre de las ganaderías.

¿Qué dicen? Un silencio con hedores reposa.
Estamos con un cuerpo presente que se esfuma,
con una forma clara que tuvo ruiseñores
y la vemos llenarse de agujeros sin fondo.

¿Quién arruga el sudario? ¡No es verdad lo que dice!
Aquí no canta nadie, ni llora en el rincón,
ni pica las espuelas, ni espanta la serpiente:
aquí no quiero más que los ojos redondos
para ver ese cuerpo sin posible descanso.

Yo quiero ver aquí los hombres de voz dura.
Los que doman caballos y dominan los ríos:
los hombres que les suena el esqueleto y cantan
con una boca llena de sol y pedernales.

I have seen grey showers move towards the waves
raising their tender riddled arms,
to avoid being caught by the lying stone
which loosens their limbs without soaking up the blood.

For stone gathers seed and clouds,
skeleton larks and wolves of penumbra:
but yields not sounds nor crystals nor fire,
only bull rings and bull rings and more bull rings without
 walls.

Now, Ignacio the well born lies on the stone.
All is finished. What is happening? Contemplate his face:
death has covered him with pale sulphur
and has placed on him the head of a dark minotaur.

All is finished. The rain penetrates his mouth.
The air, as if mad, leaves his sunken chest,
and Love, soaked through with tears of snow,
warms itself on the peak of the bull ranches.

What are they saying? A stenching silence settles down.
We are here with a body laid out which fades away,
with a pure shape which had nightingales
and we see it being filled with depthless holes.

Who creases the shroud? What he says is not true!
Nobody sings here, nobody weeps in the corner,
nobody pricks the spurs, nor terrifies the serpent.
Here I want nothing else but the round eyes
to see this body without a chance of rest.

Here I want to see those men of hard voice.
Those that break horses and dominate rivers;
those men of sonorous skeleton who sing
with a mouth full of sun and flint.

Aquí quiero yo verlos. Delante de la piedra.
Delante de este cuerpo con las riendas quebradas.
Yo quiero que me enseñen dónde está la salida
para este capitán atado por la muerte.

Yo quiero que me enseñen un llanto como un río
que tenga dulces nieblas y profundas orillas,
para llevar el cuerpo de Ignacio y que se pierda
sin escuchar el doble resuello de los toros.

Que se pierda en la plaza redonda de la luna
que finge cuando niña doliente res inmóvil;
que se pierda en la noche sin canto de los peces
y en la maleza blanca del humo congelado.

No quiero que le tapen la cara con pañuelos
para que se acostumbre con la muerte que lleva.
Véte, Ignacio: No sientas el caliente bramido.
Duerme, vuela, reposa: ¡También se muere el mar!

4. *Alma ausente*

No te conoce el toro ni la higuera,
ni caballos ni hormigas de tu casa.
No te conoce el niño ni la tarde
porque te has muerto para siempre.

No te conoce el lomo de la piedra,
ni el raso negro donde te destrozas.
No te conoce tu recuerdo mudo
porque te has muerto para siempre.

El otoño vendrá con caracolas,
uva de niebla y montes agrupados,
pero nadie querrá mirar tus ojos
porque te has muerto para siempre.

Here I want to see them. Before the stone.
Before this body with broken reins.
I want to know from them the way out
for this captain strapped down by death.

I want them to show me a lament like a river
which will have sweet mists and deep shores,
to take the body of Ignacio where it loses itself
without hearing the double panting of the bulls.

Loses itself in the round bull ring of the moon
which feigns in its youth a sad quiet bull:
loses itself in the night without song of fishes
and in the white thicket of frozen smoke.

I don't want them to cover his face with handkerchiefs
that he may get used to the death he carries.
Go, Ignacio; feel not the hot bellowing.
Sleep, fly, rest: even the sea dies!

4. Absent Soul

The bull does not know you, nor the fig tree,
nor the horses, nor the ants in your own house.
The child and the afternoon do not know you
because you have died for ever.

The back of the stone does not know you,
nor the black satin in which you crumble.
Your silent memory does not know you
because you have died for ever.

The autumn will come with small white snails,
misty grapes and with clustered hills,
but no one will look into your eyes
because you have died for ever.

Porque te has muerto para siempre,
como todos los muertos de la Tierra,
como todos los muertos que se olvidan
en un montón de perros apagados.

No te conoce nadie. No. Pero yo te canto.
Yo canto para luego tu perfil y tu gracia.
La madurez insigne de tu conocimiento.
Tu apetencia de muerte y el gusto de su boca.
La tristeza que tuvo tu valiente alegría.

Tardará mucho tiempo en nacer, si es que nace,
un andaluz tan claro, tan rico de aventura.
Yo canto su elegancia con palabras que gimen
y recuerdo una brisa triste por los olivos.

Because you have died for ever,
like all the dead of the Earth,
like all the dead who are forgotten
in a heap of lifeless dogs.

Nobody knows you. No. But I sing of you.
For posterity I sing of your profile and grace.
Of the signal maturity of your understanding.
Of your appetite for death and the taste of its mouth.
Of the sadness of your once valiant gaiety.

It will be a long time, if ever, before there is born
an Andalusian so true, so rich in adventure.
I sing of his elegance with words that groan,
and I remember a sad breeze through the olive trees.

STEPHEN SPENDER AND J. L. GILI

Poem of the Bull

Summer has filled the valleys of Spain with red streamers and whispers of dry gold. A lean, dry breeze is blowing: the breeze St. John of the Cross feared would wither the flowers of his *Cántico.* The breeze Góngora said was blowing "through a hundred mouths." A breeze like a huge breast of sand sown with tiny cactuses is bringing hot mist from the Pass of Pancorbo to the white wall of Cádiz, which surprised Lord Byron in his first dream.

In the north it is drizzling. The waves are soaking up the silvery grays of England. But there, too, it is warm. Amid moist greens that try in vain to be European are the tawny tower, the shapely hips of a girl, the scandal and unmistakable stamp of all that is Hispanic.

When one thinks of Spain, one remembers its shape on the map. Children know that France is shaped like an espresso pot, and Italy, a riding boot. They can see the elephant's trunk of India giving a gentle push to Ceylon, and they know that Sweden and Norway are a curly-haired dog swimming in a sea of cold. Iceland is a rose on the cheek of the armillary sphere. Perhaps little children cannot imagine the shape of Spain, but we adults know—our teachers told us so—that Spain stretches out like a bull's hide. Spain is not an anaconda, like Chile; it has the shape of an animal hide, and a sacrificial animal at that. In this geographical symbol lies the deepest, most dazzling and complex part of the Spanish character.

In the midst of the Iberian summer one glimpses a sharp, fleeting black form, one so full of passion it makes us shiver. A lovely, leaping form that one beholds with respect,

with fear, and amazingly, with deep joy. On its head is the "half-moon" of which Góngora once spoke: two sharp horns, the source of its power and wisdom.

Out of the Iberian summer comes a bellow that makes children cry at the breasts of their nannies and people bolt their doors along the little streets that go down to the Guadalquivir and the Tormes. The bellow comes not from a stable, with its sweet, sleepy straw; not from an oxcart; not from the horrible provincial slaughterhouses, filthy with the unending kill. It comes from a bullring, from an ancient temple, and it zigzags across the sky pursued by a hailstorm of warm human voices.

That bellow of pain comes from the frenzy of the bullring, and it expresses an ancient communion, a dark offering to the Tartesian Venus of the Dew, who was alive before Rome and Jerusalem had raised their city walls. It is offered in sacrifice to the sweet mother-goddess of all cows, queen of the Andalusian bull ranches, all but forgotten by the civilization which now stands near the lonely salt marshes of Huelva.

In the midst of the Iberian summer they open the rings—the altars. Man sacrifices the brave bull, offspring of the sweet cow, goddess of the dawn, who is alive in the dew. And the huge heavenly cow, a mother whose blood is always being shed, demands that man, too, be sacrificed. Each year the best bullfighters fall, torn apart by the sharp horns of bulls who, for one terrible moment, exchange their role of victims for that of sacrificers, as though the bull, obeying some secret instinct or unknown law, had chosen to carry away the most heroic torero, delivering him (as in the tauromachy of Crete) to the purest, most delicate Virgin.

From Pepe Hillo to my unforgettable Ignacio Sánchez Mejías, from Espartero and Antonio Montes to Joselito, there is a chain of glorious deaths: the deaths of Spaniards sacrificed by a dark religion which almost no one understands. That religion burns like a perpetual flame before the

gallantry, refinement, generosity, and ambitionless bravura of the Spanish people. The Spaniard feels swept away by a grave force which makes him play with the bull. This is an irrational force which cannot be explained, even by the person who feels it. Perhaps it comes to us from the dead, who stare at us from the motionless fence around the bullring of the moon.

They say that the torero goes to the ring to earn money, prestige, glory, applause . . . but this is not true. He goes to the ring to be alone with the bull, an animal he both fears and adores, and to whom he has much to say. The torero enjoys applause, but he is so absorbed in the ritual that he hears and sees the public as though it were in another world. And in fact it is. The public is lost in a world of creation and constant abstraction. It is the only public composed not of spectators but of actors. Each person in the audience fights the bull along with the torero, not by following the flight of the cape, but by using another imaginary one that moves differently from the one in the ring.

And thus the torero bears the yearning of thousands of people, and the bull plays the leading role in a collective drama.

The urge to face the bull claws like a mountain lion at the hearts of young boys, and this happens long before they realize that bullfighting is an exquisite art with its own geniuses, history, and schools. This urge is at the very root of the fiesta, and beats eternally in the breasts of Spaniards. All Spaniards perform along with the torero, and when he does a verónica in the style of Belmonte or executes a farol near the very head of the bull, in the style of Rafael el Gallo, Spaniards see it as something natural rather than something miraculous.

Among working-class boys, this longing to go to the bulls is so agonizingly strong that it makes them risk death. For the sake of a few passes with the cape—passes which often end fatally—many of them leap the fence at the bull-

ring with only a piece of red cloth for a cape and a stick for a sword. They are the *Ecce Homos* of the fiesta. Others take off their clothes and swim across rivers. Naked in the moonlight they expose their defenseless bodies to a thousand wounds. Or they journey over mountains and plains, burning with the desire for a beautiful death or dreaming of wrapping the bull around their waists: the supple waists of the "chosen." Not long ago, a boy who wanted to be a torero told me, "I was alone in the fields yesterday, and I suddenly felt so much love that I began to cry."

The *Fortis salmantina* (the tower of Salamanca rising over the Tormes) and the Giralda tower at the Cathedral of Seville (peering into the Guadalquivir and dressed up like a mule for the fair) are the two minarets that preside over our love for the bulls. The *pasodoble* played at the bullfights has Andalusian blood, and all schools and arts of bullfighting come from south of the Sierra Morena. But today Salamanca and tawny Castile breed fighting bulls for every ring in Spain. The fighting bull can grow only in the marshes of the Guadalquivir (river of Fernando de Herrera and Góngora) or on the plains of the Tormes (river of Lope de Vega and Fray Luis de León). That bull is truly fierce, a stranger to agriculture, and when it is taken to the tender, quiet spaces of Galicia it turns into a useful ox after a single generation.

Beneath those two high towers—the one in Salamanca, all theology, and the one in Seville, all song—we have the living drama of desire that I have been describing. A drama that is now making the Spanish mountains and valleys tremble with red streamers and whispers of dry wheat. From the bells of Salamanca (steeped in Renaissance culture) to the bells of Seville (burnished by the medieval Orient) there is a rosary of wounded breasts, a zigzag of golden tassels, and a huge black bull. Black bull of shadow whose bellowing slams doors in little villages and sounds clarions of death in the hearts of poor boys, the ones who long most deeply for the bull.

Danza da lua en Santiago

¡Fita aquel branco galán,
olla seu transido corpo!

E a lúa que baila
na Quintana dos mortos.

Fita seu corpo transido,
negro de somas e lobos.

Nai: A lúa está bailando
na Quintana dos mortos.

¿Quén fire potro de pedra
na mesma porta do sono?

¡E a lúa! ¡E a lúa
na Quintana dos mortos!

¿Quén fita meus grises vidros
cheos de nubens seus ollos?

¡E a lúa! ¡E a lúa
na Quintana dos mortos!

Déixame morrer no leito
soñando con froles d'ouro.

Nai: A lúa está bailando
na Quintana dos mortos.

Dance of the Moon in Santiago

Regard that white gallant,
look at his spent body!

It is the moon that dances
in the Courtyard of the Dead.

Look at his spent body,
blackened with shadows and wolves.

Mother, the moon is dancing
in the Courtyard of the Dead.

Who wounds the stone foal
at the very portal of sleep?

It is the moon! It is the moon
in the Courtyard of the Dead!

Who stares at my gray glasses
his eyes filled with clouds?

It is the moon! It is the moon
in the Courtyard of the Dead!

Let me perish in my bed
dreaming of golden flowers.

Mother, the moon is dancing
in the Courtyard of the Dead.

¡Ai filla, co ar do céo
vólvome branca de pronto!

Non é o ar, é a triste lúa
na Quintana dos mortos.

¿Quén brúa co-este xemido
d'imenso boi melancónico?

Nai: E a lúa, é a lúa
na Quintana dos mortos.

¡Sí, a lúa, a lúa
coronada de toxos,
que baila, e baila, e baila
na Quintana dos mortos!

Casida de los ramos

Por las arboledas del Tamarit
han venido los perros de plomo
a esperar que se caigan los ramos,
a esperar que se quiebren ellos solos.

El Tamarit tiene un manzano
con una manzana de sollozos.
Un ruiseñor apaga los suspiros
y un faisán los ahuyenta por el polvo.

Pero los ramos son alegres,
los ramos son como nosotros.
No piensan en la lluvia y se han dormido,
como si fueran árboles, de pronto.

Ay, daughter, with the wind of the sky
I turn suddenly white!

It is not the wind but the sad moon
in the Courtyard of the Dead.

Who bellows with this moan
of a great melancholy ox?

Mother: The moon, it is the moon
in the Courtyard of the Dead.

Yes, the moon, the moon
crowned with furze
that dances, dances, dances
in the Courtyard of the Dead.

NORMAN DI GIOVANNI

Casida of the Branches

Along the groves of the Tamarit
the leaden dogs have come
to wait for the branches to fall,
to wait for them to break themselves alone.

The Tamarit has an apple tree
with an apple of sobs;
a nightingale hushes the sighs
and a pheasant drives them away through the dust.

But the branches are happy,
the branches are like ourselves.
They do not think of the rain and they've fallen asleep,
suddenly as if they were trees.

Sentados con el agua en las rodillas
dos valles esperaban al otoño.
La penumbra con paso de elefante
empujaba las ramas y los troncos.

Por las arboledas del Tamarit
hay muchos niños de velado rostro
a esperar que se caigan mis ramos,
a esperar que se quiebren ellos solos.

Casida del llanto

He cerrado mi balcón
porque no quiero oír el llanto,
pero por detrás de los grises muros
no se oye otra cosa que el llanto.

Hay muy pocos ángeles que canten,
hay muy pocos perros que ladren,
mil violines caben en la palma de mi mano.

Pero el llanto es un perro inmenso,
el llanto es un ángel inmenso,
el llanto es un violín inmenso,
las lágrimas amordazan al viento,
y no se oye otra cosa que el llanto.

Seated, with water to the knees,
two valleys await the autumn.
Dusk, with the step of an elephant,
pushed aside the branches and the tree trunks.

Along the groves of the Tamarit
there are many children with veiled face
waiting for my branches to fall,
waiting for them to break themselves alone.

STEPHEN SPENDER AND J. L. GILI

Casida of the Lament

I have shut my balcony
because I do not want to hear the weeping,
but from behind the grey walls
nothing else is heard but the weeping.

There are very few angels that sing,
there are very few dogs that bark,
a thousand violins fit into the palm of my hand.

But the weeping is an immense dog,
the weeping is an immense angel,
the weeping is an immense violin,
the tears muzzle the wind,
nothing else is heard but the weeping.

STEPHEN SPENDER AND J. L. GILI

Gacela de la raiz amarga

Hay una raíz amarga
y un mundo de mil terrazas.

Ni la mano más pequeña
quiebra la puerta del agua.

¿Dónde vas, adónde, dónde?
Hay un cielo de mil ventanas
—batalla de abejas lívidas—
y hay una raíz amarga.

Amarga.

Duele en la planta del pie,
el interior de la cara,
y duele en el tronco fresco
de noche recién cortada.

¡Amor, enemigo mío,
muerde tu raíz amarga!

Gacela of the Bitter Root

There is a bitter root
and the world has a thousand terraces.

Nor can the smallest hand
shatter the door of water.

Where are you going, where, oh where?
The sky has a thousand windows
—battle of livid bees—
and there is a bitter root.

Bitter.

The ache in the sole of the foot
is the ache inside the face,
and it aches in the fresh trunk
of night only just lopped off.

Love, my enemy,
bite your bitter root!

<div align="right">EDWIN HONIG</div>

Notes

Deep Song

"Cante jondo. Primitivo canto andaluz." This lecture of 1922 was rewritten in 1930, and the new version, entitled "Architecture of Deep Song," was read in Cuba, Spain, Buenos Aires, and Montevideo in 1930–34. The distinction between deep song and flamenco, an important one to Lorca and Falla, is seldom made today: most flamencologists consider cante jondo as one area of flamenco. Much of Lorca's historical information, drawn from Falla, has been questioned by recent scholarship: for example, the formative influence of Byzantine chant; the strictly "rural" origin of deep song; its antiquity vis-à-vis flamenco; and the greater purity of the singing of amateurs (a premise of the 1922 Festival). The Gypsies' role in the creation of deep song is much debated. For an excellent scholarly discussion of "Deep Song," see the articles of Israel J. Katz in *New Grove Dictionary of Music and Musicians*. On Lorca's lecture, see Timothy Mitchell, *Flamenco Deep Song* (New Haven: Yale University Press, 1994) and Christopher Maurer, *Federico García Lorca y su "Arquitectura del cante jondo"* (Granada: Casa-Museo de FGL, 1997). There is a recording of Lorca's personal collection of flamenco music, including several pieces recorded in 1922 shortly after the Festival of Deep Song: *Colección Federico García Lorca* . . . Sonifolk CD 20106, 1997, with liner notes by C. Maurer.

1. Antonio Fernández Grilo (1845–1906), a stupefying poetaster.

2. The Vela is a bell in one of the watchtowers of the Alhambra, rung at intervals to regulate the opening and closing of the irrigation channels in the river plain below, called the Vega.

3. The liturgical rite called "Chant and Dance of the Sibyl" has sometimes been performed in the Seville Cathedral (see also p. 57). Heraclitus's fragment on Cassandra sounds like Lorca on the cantaora: "with inspired lips she utters words that are mirthless, without ornament, and without perfume, but through the power of the god her voice reaches across a thousand years.

4. Lorca uses this song in *The Billy Club Puppets*, Scene II.

5. Sung by the heroine in *Mariana Pineda*, Act I, Scene VII.

6. This is probably Ibn Sa'īd al-Magribi (d. 1274), who compiled an anthology which his Spanish translator calls "the last testament of Arabic Andalusian poetry." Perhaps Siraj-al-Warak is Ibn al-Warraq, the medieval poet. Lorca was quoting here and in the following poems from translations far removed from the originals.

7. The image comes from an old siguiriya associated with Silverio: "Yo no sé por dónde / al espejito donde me miraba / se le fue el azogue" (I don't know what happened to the mercury in the mirror I once used.)

Note on the Guitar

Fragment of "Architecture of Deep Song," published in a Sevillian newspaper in March, 1932.

The *Niño de Huelva,* who won a guitar prize at the Festival of 1922, is the professional name of Manuel Gómez Vélez (1892–1976), the accompanist of Manuel Torre, Antonio Chacón, Tomás Pavón, and *La Niña de los Peines.*

Baetica: Lorca is alluding to Roman Andalusia, specifically Seville, on the shores of the "Baetis" (Guadalquivir).

Guitar, Riddle of the Guitar

From *Poema del cante jondo* (Poem of the Deep Song), written 1921 and published 1931.

Poem of the Saeta

From *Poema del cante jondo.* The saeta (literally, "arrow" or "dart") is a devotional song sung during the Holy Week procession. It is often sung from a balcony when the floats carrying statues of Christ and the Virgin pass below in the streets. In 1923 Lorca and his brother accompanied Falla to Seville during Holy Week in search of "a pure, unadulterated saeta." The word *lirio* in "Arrow" and "Early Morning" is better translated as "iris."

Rider's Song

Written July 4, 1924, and published in *Canciones* (Songs), 1927.

Farewell

From *Canciones* (Songs), 1927. Date of composition unknown. Line 6 might also be translated: "From my balcony I feel (sense) him."

The Death of Antoñito el Camborio

Undated. Published in *Primer romancero gitano* (First Gypsy Ballad Book), 1928. Lorca wrote that Antoñito, who seems to be put to death for an offense against family honor, is one of the "purest heroes" of his *Ballads,* "the only one in the book who calls me by name at the moment of his death. A true gypsy, incapable of evil." See *Deep Song and Other Prose* (New York: New Directions, 1980), p. 117.

Ballad of One Doomed to Die

Published in Primer *romancero gitano*, 1928. Lorca writes of Amargo: "When I was eight years old and was playing in my house at Fuente Vaqueros, a boy looked in the window. He seemed a giant, and he looked at me with scorn and hatred I shall never forget. As he withdrew he spit at me, and I heard a distant voice calling, 'Amargo, come!' After that the Amargo [literally, 'the bitter one'] grew inside me until I could decipher why he looked at me that way, an angel of death and of the despair that guards the doors of Andalusia. This figure is an obsession in my poetic work. By now I do not know whether I saw him or if he appeared to me or if I imagined him, or if he has been waiting all these years to strangle me with his bare hands. The first time the Amargo appears is in *Poem of the Deep Song,* which I wrote in 1921" (*Deep Song and Other Prose,* pp. 117–118).

Play and Theory of the Duende

"Juego y teoría del duende" was first given in Buenos Aires in 1933.

1. Manuel Torre (1878–1933) was one of the first cantaores to sing cante jondo in a natural voice—from the chest, not from the throat. When Lorca met him in December 1927, he heard Torre say, "What you must search for, and find, is the black torso of the Pharoah." (Torre was a Gypsy and thus thought himself of Egyptian origin.)

2. See Eckermann's *Conversations with Goethe* (entries for February 28 and March 2, 1931) and Part IV, Book XX of Goethe's autobiography.

3. Silverio is Silverio Franconetti y Aguilar, a cantaor born of Italian parents in Seville in 1834. Lorca says in a poem: "The dense honey of Italy / and our own lemon / were in his deep weeping." The siguiriya is a form of deep song whose words fall in tercets or quatrains of 6-6-11-6 syllables.

4. From the traditional ballad that begins, "Paseábase Marbella . . ."

5. From the Salamanca folksong "Los mozos de Monleón," one of the folk tunes which Lorca recorded in 1931 with the singer *La Argentinita.*

6. Reference to Act 21 of *La Celestina* by Fernando de Rojas.

7. From the traditional "Romance del palmero" (Pilgrim's Ballad).

8. From *Cancionero musical del palacio*, an early sixteenth-century songbook reprinted in 1890 by F. Asenjo Barbieri.

9. "A San Andres de Teixido vai de morto o que no fuoi de vivo," says a Galician proverb: whoever does not visit San Andrés while living must do so after death. The dead crawl to that sanctuary, 10 km. from La Coruña, in the form of reptiles and insects.

10. On All Soul's Day, November 2.

11. A religious procession in the Catalan town of Tortosa on the eve of Palm Sunday. There is a firsthand account, with music, in Felipe Pedrell's *Cancionero musical popular español.*

12. Lorca probably refers to Juan de Herrera (1530–1597), architect of the Escorial, mentioned earlier.

13. Reference to the seven lagoons of Ruidera, the oasis in La Mancha where Don Quixote descended to the Cave of Montesinos. The soporific anemones allude to the satirical *Sueños* (Dreams) of Francisco de Quevedo.

In Praise of Antonia Mercé, La Argentina

Read at an homage (February 5, 1930) to the Spanish dancer (Buenos Aires, 1889–Bayonne, 1936) who was on a tour of the U.S. while Lorca was in New York. Not to be confused with *La Argentinita*, Encarnación López Júlvez, with whom he recorded a series of popular Spanish songs.

Lament for Ignacio Sánchez Mejías

Written 1934, published 1935, in commemoration of Lorca's friend the bullfighter Ignacio Sánchez Mejías (1891–1934), who was gored in the thigh in a provincial bullring at Manzanares and died days later of gangrene poisoning.

Poem of the Bull

Title given posthumously to a transatlantic radio broadcast in August 1935. Lorca views the corrida here as a ritual sacrifice originating in the oldest civilization in Europe, Tartessos, which flourished in the delta of the Guadalquivir, near modern-day Huelva, from about 1,000 B.C. Presiding over the ritual sacrifice, in this syncretic vision, is the Virgin of the Dew, the mother-figure venerated by An-

dalusians in the *Romería del Rocío,* an annual pilgrimage to the marshes of the Guadalquivir. Lorca sees this Virgin, patroness of bullfighters, as the Moon Goddess or Great Goddess worshiped by primitive civilizations.

Dance of the Moon in Santiago

From Seis *poemas galegos* (Six Galician Poems), published in 1935. "The courtyard of the dead" refers to a small plaza in Santiago de Compostela, next to the cathedral, the former cemetery of the canons.

Casida of the Branches, Casida of the Lament, Gacela of the Bitter Root

From *Diván del Tamarit* (Divan of the Tamarit), written 1931–34 and published posthumously in 1940.